The Art of
SPECIAL EFFECTS

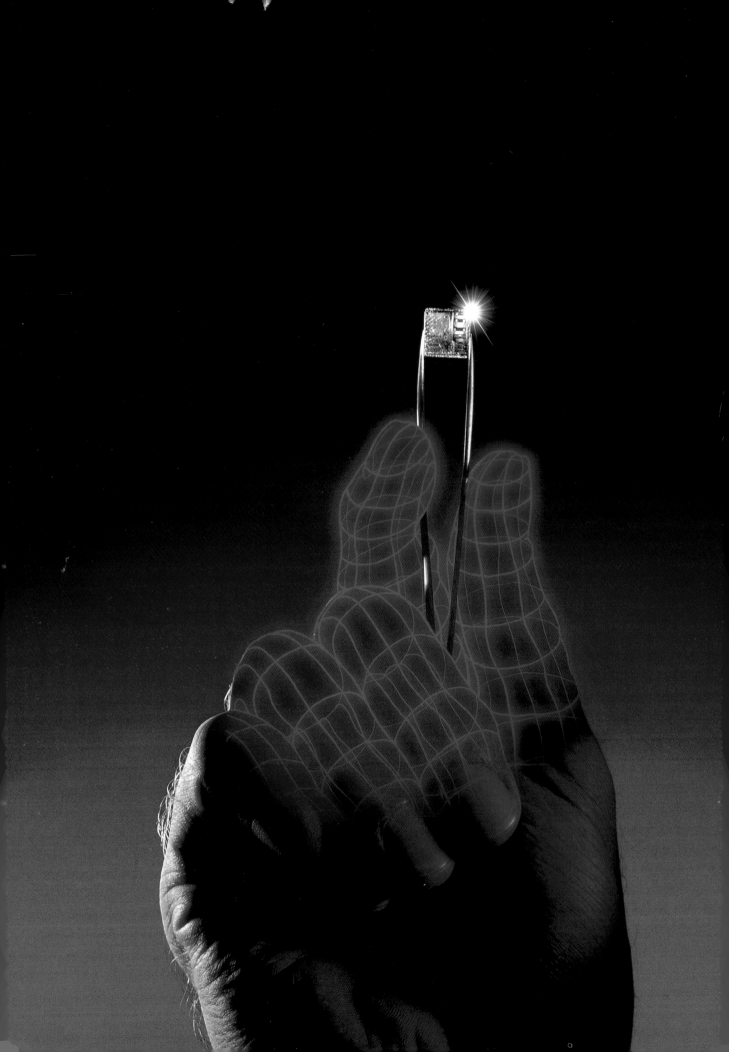

The Art of SPECIAL EFFECTS

MARTIN SAGE

AMPHOTO
An imprint of Watson-Guptill Publications/New York

ACKNOWLEDGEMENTS

When I began this project four years ago, I never dreamed that writing a book could be so involved. From the original idea, to completion, I know I'd never have succeeded without the immeasurable help of the following generous, dedicated, and gifted individuals:

At AMPHOTO, my thanks to Marisa Bulzone, the first person to say, "Yes," my idea for a book was a good one; Robin Simmen, who took the first rough draft and made sense of it; Susan Hall, who continued to refire my enthusiasm for the project; and Philip Clark, who took the ball and ran with it—his help, his calm determination to see this project to completion, has been invaluable throughout the process.

Thanks also to master photographers Pete Turner, Michel Tcherevkoff, Jayme Odgers, Ron Shirley, Peter Hogg, Alan Chernin, and Richard Wahlstrom, who all gave generously of themselves to help a fellow photographer—I shall always be in their debt.

To my wife, Audrey, whose love, support, optimism and skill in taking my feverishly scribbled notes and turning them into a book, endless thanks.

Finally, to my dog, Jim, who patiently took me for long walks to muddle over together what I had written . . . here's the biggest hot dog in the world. . . .

My thanks to you all!

Designed by Bob Fillie
Edited by Philip Clark
Graphic production by Ellen Greene

Copyright © 1989 by Martin Sage
First published 1989 in New York by AMPHOTO
an imprint of Watson-Guptill Publications,
a division of Billboard Publications, Inc.,
1515 Broadway, New York, NY 10036

Library of Congress Cataloging-in-Publication Data
Sage, Martin.
 The art of special effects : backlit graphics and copystand
photography / Martin Sage.
 p. cm.
 ISBN 0-8174-3545-X—ISBN 0-8174-3546-8 (pbk.)
 1. Photography—Special effects. I. Title.
TR148.S24 1989
778.8—dc20 89-38442
 CIP

1 2 3 4 5 6 7 8 9 / 97 96 95 94 93 92 91 90 89

CONTENTS

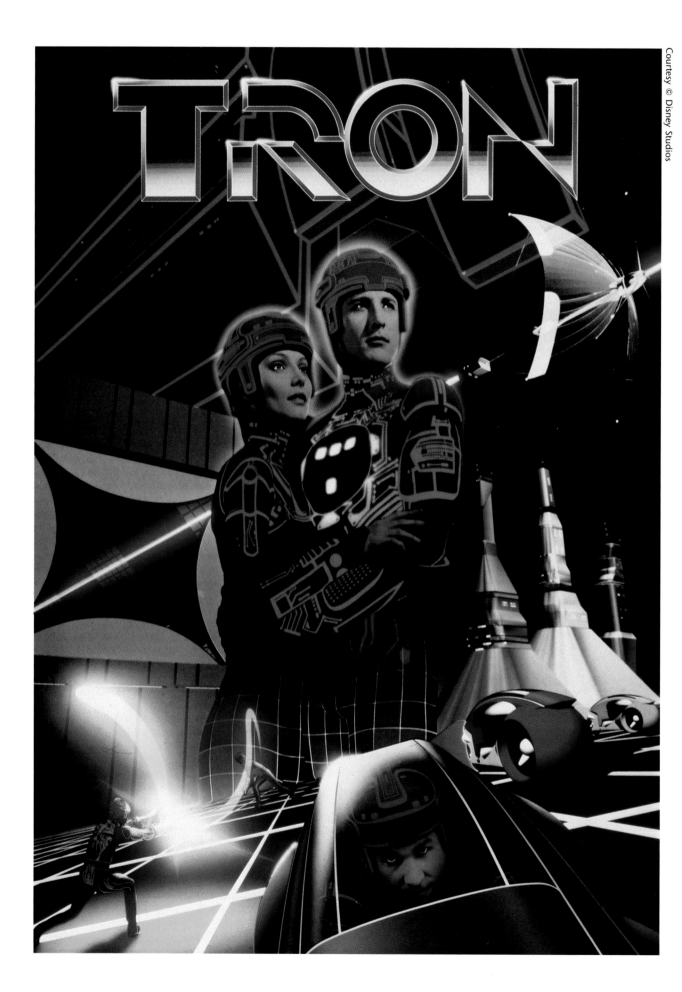

INTRODUCTION

FOR AS LONG as people have contemplated the world, they have been fascinated by the seemingly impossible and, thereby, unexplainable. Ancient history abounds in tales of wizards and sorcerers who possessed supernatural powers and performed magical feats that kept our ancestors enthralled. Today's Merlins are the special-effects artists—a group of very creative talents whose skills have kept us spellbound with their particular form of magic in movies, such as *Tron, Dune, Star Wars, Poltergeist,* and *Who Framed Roger Rabbit?*

With the introduction of increasingly sophisticated computer graphics in the film industry, the old ways of creating special effects for print advertising have begun to lose appeal. The public now expects to see in print the same dynamic visual effects they have been enjoying on the big screen. The techniques that produce these effects commonly include backlit graphics and photo compositing. These methods enable artists to combine a whole universe of various objects and scenes into a single powerful image. Today's high-tech still photography is still growing in amazing new ways. Backlit graphics and copystand photography are part of today's most technological applications in design and art direction. Photography has seen the crossover of traditional forms of illustration and the incorporation of advanced techniques of backlit graphics and image manipulation.

The purpose of this book is to introduce you to the wonderful possibilities these special-effects techniques offer. Copystand photography and backlit graphics will open up a vast new resource of imaginative effects that can be combined with standard photographic processes. The equipment is not excessively complicated, nor the methods needlessly time-consuming.

The methods and actual projects I illustrate come from my professional work for commercial clients in the industry. By using the step-by-step examples I created for them, you will get a clear idea of the range of work and techniques being done in the field today.

As you will see, there are many ways in which you can set up a basic copystand work area. The major component, the copystand, can be purchased from many camera stores, but I will also show you how to build your own. The other equipment and materials are readily available in most art supply stores.

Creating backlit graphics and special effects on a copystand really starts with your imagination. But even the most complex ideas must start with a simple understanding of how to use your equipment and how to execute the processes described in this book. You will often combine photographic images with art that you will create—such effects as starfields, horizon glows, and neon effects. You don't have to be an accurate illustrator; much of the artwork can be found already drawn in magazines or stock art books. There are three main processes: making a comp, or visual rendering in rough form, of your idea; preparing the separate materials at your light table in the art prep area; and, finally, photographing them on your copystand.

The method of photo compositing will introduce you to creating mattes and multiple exposures. Mattes will enable you to produce a single image by combining more than one element: this method will help you bring to life every idea you can imagine, and every feat of visual magic you create can be repeated time and again, with new variations. So, if you have an idea of showing violins suffused with the "glow" of music, you can bring such a concept to photographic reality. Or, if you want to show a computer floating above the surface of the earth, creating a drop shadow effect will let you do this. Start simple, understand the materials and processes, and repeat them until you can complete each project with your eyes closed.

In the chapters that follow, I will introduce you to the equipment and materials of copystand photography, show you how to create a variety of backlit-graphics effects you can incorporate in your photographs, instruct you in the methods of making photo composites and multiple exposures, and explain to you the various processes involved in producing finished projects. At the end, you will see a selection of work by other photographers who are successfully developing backlit-graphics techniques.

Your ideas are limited only by your imagination, and in reading further I think you will see how far your imagination can reach.

EQUIPMENT AND MATERIALS

ELEMENTS
OF COPYSTAND PHOTOGRAPHY

SPECIAL-EFFECTS backlit graphics and copystand photography are in a creative realm of their own; the techniques and the equipment involved differ from that used for making photographs with a handheld camera. The images created on a copystand always involve photographing a flat, one-dimensional field. Special lenses and a variety of other materials are required. Care must be taken with the work, as it is an exacting process, although your precision and patience are rewarded with wonderful creative possibilities. As with any medium, once you have learned to use the particular tools needed, you will acquire the ability to let your imagination use them to its fullest. While copystand photography does require more than simple tools and materials, they are not difficult to work with, nor are they necessarily very expensive.

The basic process of copystand work is illumination of art on a flat surface. The light di-rected up to the copystand work surface is then used with a variety of filters to add color, or diffusion materials (such as Flexiglas and Plexiglas) to create soft-focus glows, gradations, and blends. It is the light itself, which you "draw" with, that creates the special effects.

You will harness this light with mattes, which are exact silhouettes of actual objects you wish to position in your image. These silhouettes will be combined with other effects and elements, and then sandwiched, or composited together, by photographing them with the copystand camera and lens. You begin with an idea, sketch its individual elements, create the separate pieces of art, create mattes for each element, and then composite them into a single image. The material used primarily to make mattes is high-contrast litho film. In any given image this film will reduce its tonal values to either total black, or white (the film becomes transparent in this case). Negatives or positives can be made of any

high-contrast image on litho film. The negative is the matte; the positive acts as the "window" for purposes of combining separate elements of each image.

For my work in this field, I have the added resource of a studio, in which I produce most of my art. To some this may be a luxury, but a studio is within anyone's reach, even if you don't have a specific area set up as such. Improvising and a little building will produce results in even a small room. Let's take a look at the equipment and materials that will launch you toward making great images.

STUDIO LAYOUT

One of the best elements about special-effects work is that it does not require huge spaces to work in. Even if you don't have a room for every area described here, you can manage quite easily. My entire studio space measures 22 × 100 feet. I have broken it down into the three main work areas: the shooting area (cove); the art prep area, where I prepare my art and lithos and draw most of my comps; and the darkroom, which includes my workstation and copystand equipment for actual matte and litho prep work, exposures, and photo compositing.

The Shooting Area. By most standards, my shooting area is small: only 22 × 40 feet. This is where I set up and photograph almost all of my products for commercial assignments. I have built a permanent cove, which measures 20 feet wide, at one end of it. The cove is a hard, curved surface constructed out of bent drywall or particle board; it can provide a seamless background that is excellent for large or small objects. If I can fit something into the cove, I can shoot it. And, because I replace most of the original backgrounds in my final composites, I have the flexibility to use the cove as a neutral set for anything I photograph. If needed, I can paint the cove a light color (or any color I choose), or hang black velvet or black seamless paper for a solid, dark background.

You can make coves by hand with some work if you're feeling industrious, or you can purchase prefabricated coves in interlocking, modular units (see the Directory of Suppliers on page 139.) If you do not have the option of purchasing a cove, you can improvise in many ways, depending on your particular setup—anything from a large wall to seamless hung or nailed up will suffice. The size of your shooting area depends on one factor: the size of the object you are shooting.

The Art Prep Area. This section of my studio is

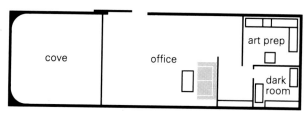

The layout of my studio permits convenient access to the important work and studio areas. At the far left is the cove, where I set up and photograph some of my largest projects. The other end of the studio is the production office. My darkroom and art prep areas, at far right, are where I do my copystand and backlit-graphics work.

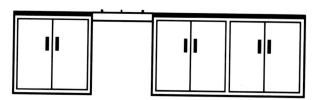

Front view of my light table and storage cabinets. The light table includes a pin-registration system exactly like the one I have on my copystand. In both cases, this is where I mount all my materials and prepare them for photo compositing at my workstation.

The cove is constructed out of five sections, which are assembled together and then painted a neutral color for use as a background. It can be repainted as many times as needed to change backgrounds. If you don't plan to purchase a commercially manufactured cove, you can easily build one of your own.

where I draw my comps, prepare my artwork, and mount my transparencies. My area measures 9 × 12 feet. In this room I keep a small drafting table, a light table that I have adapted with a pin-registration system for my composites, and a Formica-covered work surface. It is most important to keep this area as clean as possible; I take extra care with all transparencies, original drawings, and lithos to make sure all work is dust-free and ready for compositing. The Formica surfaces are simple to clean up, smooth and even, as well as sturdy.

The Darkroom. My darkroom area measures only 8 × 10 feet. In it are an enlarger, a processing sink, and my workstation, which is the heart of my special-effects work. The workstation comprised of my copystand as well as the pin-registration system and backlit work surface where I create the special-effects graphics.

COMPONENTS OF THE WORKSTATION
Whether your special-effects image is composed of several transparencies or transparencies and backlit artwork, the workstation is where you

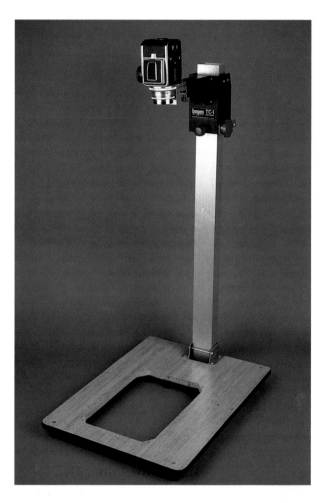

Copystands (above) are sold in a variety of sizes and styles. The basic copystand consists of a baseboard, an elevating camera shaft, a light-diffusion surface, and light sources. Your copystand base (above, right) can be custom-built and adapted for backlit-graphics work. A hole is cut into the baseboard, on which a sheet of glass and a sheet of diffusion material are placed.

The sliding camera mount (right), on which the camera and lens are raised. Notice the adjustable camera-mounting post, right, and large locking lever, left.

will bring all the parts of the image together. Basically, it is a housing for light and a surface on which to photograph and composite the separate pieces of artwork for the image. The pin-registration system is positioned on top of the work surface to align all your transparencies and artwork; the copystand houses both your cameras (for formats up to 8 × 10 view) and your copy lenses. Using these basic tools, you will have everything you need to begin your work.

Copystands. Copystands are currently available in a variety of sizes and prices, and with a host of accessories. Some come complete with a workstation housing for backlit artwork, some have lighting stands, and others are fully computerized. I strongly suggest investing in a good copystand—which may not be the most sophisticated model. What is important for your work is having a copystand with an elevating shaft and adjustable mount. This feature will enable you to move your camera up and down precisely. The shaft and mount must be solid enough to keep your camera locked in position when needed and allow for very sharp focusing. Some include calibrated measurements on the shaft. Look for these features when shopping for a copystand: a rigid base, precision machine shaft, lever-action locking, and an adjustable sliding mount.

Copy Lenses. Whether you are shooting 35mm, 4 × 5, or 8 × 10 photographs, having a flat-field copy lens is essential for making sharp, distortion-free exposures on your copystand. If you can afford it, I suggest you invest in a good 1:1 macro lens for your 35mm camera or in a quality apochromatic lens. Most normal curved-field lenses will cause the outer edges of the frame to go slightly out of focus. Copy lenses prevent this, as well as a problem called "matte travel." This refers to a distortion in the final image caused when some or all of the composited pieces are edged with a black line. This distortion occurs if you use a curved-field lens.

There are a number of excellent manufacturers of copy lenses, and each will have something in your price range (see the Resource Directory on page 141). Again, the best investment is to buy the best equipment.

Filters, Film, and Color Balance. You will be using a range of filters in your backlit special effects. When you find it necessary to make color corrections in your exposures, use color-compensating (CC) filters. They come in density increments of .05, .10, .20, .30, .40, and .50 (i.e., CC5Y = a yellow filter with .05 density). The greater the density, the deeper the color. These

A selection of colored filters photographed in soft focus. Filters will be an integral part of your backlit graphics work; they are fragile and should be handled carefully.

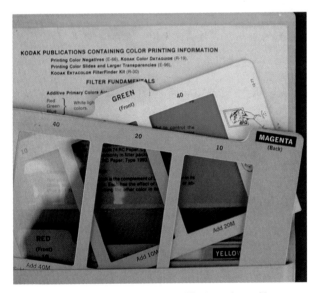

A sample of Kodak's Filter Kit. Placing these filters between your light table and the transparency you are working with will help you determine the correct color balance for your transparencies. They should be used with the Kodak Three-Point Transparency Guide to help you color-correct your exposures.

3-inch square filter gels must be placed in suitable holders. Make sure that they are clean and unscratched. You will pay a price for using bent, cut, or scratched filter gels: sharpness is the name of the game.

Different kinds of film require different filter packs for correct color balance. If you are using Kodak film, I recommend buying a Kodak Color Print Viewing Filter Kit. The filters in this kit will best help you determine the right color correction for your images.

Film used for special effects includes a variety of color films and "dupe" (duplicating) film. When I shoot a backlit graphic alone or combined with a pre-exposed original image, I use either Kodachrome or Ektachrome 64 Professional Film or Fujichrome 50 RFP for my large- and medium-format work and Kodachrome 25 for my 35mm work. (If you are using a tungsten lighting source, use Kodachrome Type A Tungsten film). These film choices give me the desired color saturation, rich blacks, and fine sharpness. When I want to duplicate a transparency for my special-effects work, I use Kodak Ektachrome SE Duplicating Film with 35mm format (Ektachrome 5071 with tungsten), or Kodak 6121 film for larger format work. Although I have never personally tried it, there is no reason why you cannot experiment with using color-negative or black-and-white films. I use Polaroid film only for exposure tests or lighting tests.

After you have decided which film will be best for the work you plan to do, purchase a large quantity of the film with the same emulsion number. All film is labeled with a number designating its emulsion batch; when you run out of a certain type of film, always try to restock with film that is numbered as closely as possible to its original emulsion batch.

Using a Transparency Guide. Another piece of film equipment that will help you is the Kodak 3-Point Transparency Guide, a standard for judging the color and density of any dupes that you make. The colors you make must match those of your original transparency in order for you to produce a true reproduction of the original. The

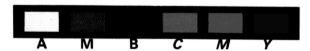

The Kodak Three-Point Transparency Guide. Each of the six squares is used to measure the color-correction and density values of a transparency. The three squares on the left, marked A, M, B, measure density of black, and the three squares on the right measure color-correction values.

density, or exposure value, must match also, in order for all the composited images to be consistent. If the density is too light, some of the highlight detail will be lost. If the density is too dark, you will lose shadow detail. By matching the three colors and densities on the transparency guide with your dupe slide, you will ensure a high-quality reproduction. To use the transparency guide most efficiently with your exposures, follow this procedure:

- Mount the guide strip in the center of a clean acetate cel, and mask the rest of the cel with black construction paper.
- Place the masked cel on the copystand, and cover it with a piece of ¼-inch-thick glass (with rounded edges for your protection).
- Fill the frame in your viewfinder with the guide strip. If you are using 4 × 5 or a larger format, include the entire strip of six squares; if you are using 2¼ or a smaller format, crop in tightly on the three *density* squares.
- Insert the starting filter pack recommended by the film's manufacturer.
- Shoot a test Polaroid to determine a ballpark exposure. When you have determined the best exposure, shoot a whole roll of film, bracketing in ½-stop increments throughout the entire *f*/stop range. With 2¼ or 35mm film, shoot the first half of the roll using only the three *density* squares, and shoot the second half of the roll using the three *color-balance* squares.
- Process the film at normal development, and record the information for use throughout the remainder of your shoot.

THE REGISTRATION SYSTEM

All of your special-effects images will be created by sandwiching more than one piece of artwork onto another. To make sure that each element of artwork is properly aligned, or in register, special equipment is needed. I use the Acme standard system. It includes clear, pre-punched acetate cels (sheets) on which each separate element is mounted, pin-bars for aligning the cels in register, and a field chart for determining the placement and size of the different elements in your image. This system is available at most art supply stores, or it can be purchased by mail (see the Directory of Suppliers on page 139).

Acetate Cels. All artwork you composite must first be mounted on a sheet of clear acetate. These transparent plastic sheets are a uniform size of 10½ × 12½ inches and are .005 inch thick. They are sold pre-punched to fit over the registration pin bar. Each of the elements in your image, whether a stat, a litho, or a transparency,

will be mounted on an acetate cel. The cels are then combined on top of the pin-registration bar, to register the elements exactly.

Pin-Registration Bar. This bar is approximately 12 inches long with a slotted pin on either end and a round pin in the center. These will match the holes pre-punched in your acetate cels. One pin-registration bar will be attached to your copystand work-surface, but you will need a second one attached to your lightbox.

The Field Chart. The field chart resembles an acetate cel, but it is .02 inch thick and made of translucent material. There are vertical and horizontal "field" numbers on it, arranged in a series from 4 field to 12 field. These are guides for framing images in your camera and for positioning artwork consistently. As the camera moves up the copystand shaft, the field sizes seen through the viewfinder increase toward 12; as the camera moves down toward the artwork, the field sizes decrease toward 4. So, for example, if you position an element in 4 field, note the vertical and horizontal numbers corresponding to that position, and mark them down. When you want to position another element on the field chart at another stage in your work, you will always be in the exact position you started.

Because the field chart is translucent, you can also use it as an overlay for positioning different elements in your composition. Again, note the numbers, and refer to them continually.

BUILDING THE WORKSTATION

Now that you have an idea of the basic equipment involved in copystand photography, let me show you how you can make your own workstation, if you choose not to buy one of the commercial copystand systems. The process is not difficult and requires only a few hours of labor. I will also show you how to adapt your copystand base to accommodate backlighting.

Workstations can be constructed out of almost any solid material, be it drywall, plywood, or particle board. What is important is that the workstation be light-tight and sturdy. Its width will be determined somewhat by the width of your copystand base. Allow three to six inches of border on each side, depending on what is comfortable for you. The height of the workstation is also a matter of personal comfort. I built mine 30 inches high because I am over 6 feet tall and do not like to stoop over constantly. The minimum height, however, should be at least 12 inches; here, you would have to place the workstation on a table or somehow raise it to a comfortable working level.

The acetate cel is the material on which to mount all artwork and transparencies before photo compositing them. It is made of thin, yet very durable plastic.

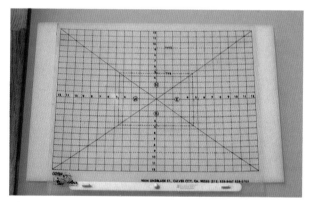

The pin-registration bar, field chart, and Plexiglas work surface of the copystand shown ready for registration and photo compositing.

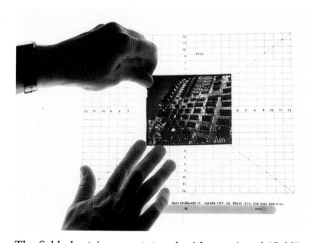

The field chart is an acetate cel with a series of "field" sizes printed on it for exact positioning of artwork. As separate elements are placed and sized on the field chart, the corresponding vertical and horizontal numbers can be noted and later used to position the next element in your composition.

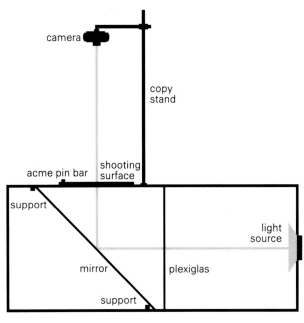

side view workstation

top view workstation

The workstation can be custom-built to suit your needs. The important component to consider is the light source; it must be set far enough back in the base to allow for the most even projection of light rays to the mirror and copystand work surface. The mirror must be angled at a precise 45 degrees. The basic housing is very simple and can be constructed from a variety of materials.

The length of the workstand is by far the most important part—the longer the better. As light rays travel through it toward the mirror and are reflected up to the copystand, they should be perpendicular. The farther away the light source is from the mirror, the more perpendicular the rays will be. This produces the most even illumination of the copystand work surface. The minimum length is approximately five feet. Painting the interior of your workstation a flat black will also prevent light rays from scattering in all directions.

When you have constructed the basic box housing, you must cut two holes into it: one on the top, where your copystand base will be, and another at the back, where your light source can be mounted. The measurements of these openings will depend on the size of your copystand base and the size of the light you use for illumination. You can use either a tungsten light or an electronic flash unit. I prefer electronic flash, or strobe light, because it is cooler and allows unlimited light output. If you choose to use tungsten, you will have to incorporate an exhaust fan into the workstation housing to prevent the heat produced by the lights from overheating the interior materials. Electronic flash units, such as the 200-watt-second strobe units, or other small, portable strobes, are perfect if you have access to limited power output. Use a unit that runs on AC, rather than on batteries: the batteries may run out of power in the middle of a project.

To bounce the illuminated light up to the copystand's work surface, you will need to insert a mirror within the housing, positioned at an exact 45-degree angle, and sized so that its edges touch all sides of the interior walls of the workstation. Secure the mirror in position with ¼-inch wood molding, glued to the sides, top, and bottom. To make the light striking the mirror as consistent as possible, position a piece of ¼-inch opaque white Plexiglas that is the height and width of the interior in between the light source and the mirror (see diagram on page 16).

Preparing the Copystand for Backlighting. After you have assembled the workstation, you will need to adapt the copystand's work surface by cutting an opening in it and positioning glass and a sheet of Plexiglas to it. The illuminated light reflected off the mirror in your workstation housing will produce the backlighting for the copystand surface.

You must make sure that the position of this opening is in exact alignment with your copystand and copy lens. The following method will help you do this:

Place your copystand and base board on a hard surface, and level them precisely with a carpenter's level.

Find the exact center of your camera's lens cap by drawing two intersecting lines across it. Next, take a needle and thread it, and place it through the center point of your lens cap. Knot the thread, and let the needle act as a plumb. Replace the lens cap on your lens, and raise the lens to its farthest position away from the copystand base board (crank the elevator mechanism up until it stops).

Position your field chart on the copystand base board, and let the needle come to rest at a position on the field chart. Carefully move the field chart so that its center point is directly beneath the needle. Square the chart but *do not move from the center*. Pivot the field chart *around* that point. Remove the lens cap, and look through the viewfinder to check the center of the field chart. Replace the lens cap, and check the plumb again. To double-check the alignment, run the camera up and down the elevator shaft and look through the viewfinder. The field lines should remain square at all sizes. When you are sure that the center of the lens is perfectly aligned with the center of the field chart, tape the field chart down securely, and trace around it on the copystand base board.

Remove the field chart. Draw a neat perimeter one inch larger all around the tracing.

Cut the opening in the copystand base along this perimeter. Measure a sheet of ¼-inch-thick glass half an inch larger on all sides than the perimeter you have cut out. Cut the glass. Measure a sheet of ⅛-inch-thick white translucent Plexiglas two inches smaller on all sides than the glass over the copystand base.

Epoxy the glass to the copystand base over the hole cut into it. Position the Plexiglas, centered, over the glass and butt the pin-registration bar against the edge of the Plexiglas.

Place the field chart over the pins, and make sure everything is square and centered. Tape the field chart and the Plexiglas down securely, and slip the pin bar from under the field chart.

Run a thin bead of epoxy onto the back of the pin bar, and then carefully position it under the field chart. Let it adhere to the glass and set firmly. *(Do not glue the field chart or the Plexiglas. They are movable elements on your workstation surface; only the pin bar remains permanently attached to the glass surface.)*

A sheet of Plexiglas cut to size to be positioned on the copystand baseboard. This material is translucent and provides even surface illumination.

A top view of the copystand baseboard showing the Plexiglas diffusion surface and the holes to adhere the top sheet of glass to the work surface.

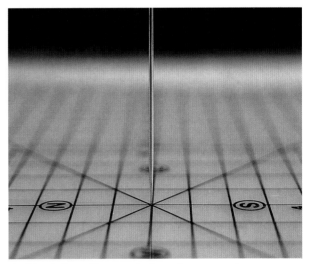

A threaded needle, attached to the center of your lenscap and suspended above the field chart, acts as a plumbline to help you find the exact center of your copy surface.

METHODS
OF MULTIPLE EXPOSURE

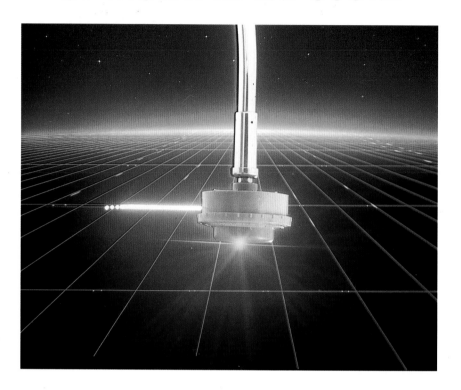

AS A YOUNG PHOTOGRAPHER, I always admired the imagination and wizardry of the surrealist illustrators and painters. Their subject matter seemed always to have limitless creative possibilities. One of my favorite artists was Magritte. He often combined ordinary objects in unusual juxtapositions. What in reality could never happen, he made possible and painted it on the canvas. I yearned for this ability in my photographic work: to be able to combine totally different images together in a single image. Discovering the art of photo compositing opened the door.

THE PHOTO COMPOSITE: MATERIALS AND PROCESSES OF MAKING MATTES

Suppose you want to illustrate a fleet of motorcycles racing through a blue sky, or a piano floating above a still lake. How do you do it? You composite the images; that is, you expose one image onto another one. But that creates a multiple exposure showing all the elements overlapping. To create a *single* image, you have to create a matte of one of the subjects to hold back a certain area and shape on your film for the second object to be exposed there.

A simple example of a matte can be seen in the following exercise. Sit in a dark room and hold your hand toward an open window. You will see a silhouette of the shape, or matte, of your hand. Now turn on a nearby lamp. The light reveals all the detail in the hand. Turn off the light again and you create a matte. In a sense, that is what a matte does—it turns off the light.

In creating backlit graphics and copystand images, you will use mattes to produce your photographs. Because mattes can be created with photographic film, you can composite a number of them together and create a single image incorporating all the elements of your final design. If

you want to have that fleet of motorcycles racing through a blue sky, mattes will enable you to create such an image.

Say you wanted to superimpose a cube on top of a textured surface. If you simply double-exposed the cube and the textured surface, the texture of the background would bleed through the shape of the cube. But if you were to composite the two images after making a matte, your final image would show a white cube on a textured background. As you can see in the illustrations, it is a matter of holding back the light in the area where the cube will appear.

Let's explore this process, and the materials used, in more detail. I will also present alternate methods of creating photo composites with non-matte processes.

MATERIALS FOR MAKING MATTES

Litho Film. Most of your mattes will be made with "litho" film, which is the term used for Kodak's Kodalith Film. This film has a high-contrast emulsion that separates all tonal values into solid black or solid white (appearing transparent). This film is excellent for holding detail while building contrast. A silhouette or matte of an object (black with clear background) is called a positive litho. It is important to understand that the reverse of any matte you create with this film will produce a "window" of the image. This window is also called a negative litho. A window is produced by simply contacting this positive litho with another clean, unexposed piece of litho film.

Rubylith Mattes. Another simple approach to creating mattes is to make them with rubylith material. This is a paper-thin, deep red plastic material sold in sheets. One side is slightly sticky and will adhere to film and litho surfaces. Its color prevents light from exposing the litho film. The key to using this material is to work large. Do not attempt to use it with anything smaller than 4 × 5, and preferably no smaller than 8 × 10 projects.

The best subjects for making mattes from rubylith are simple, clean-edged shapes. Soft-edged subjects, such as hair, clouds, and intricate machinery, should be avoided because it is almost impossible to cut the rubylith to create a precise matte outline. Litho film is a better choice for subjects with complicated or intricate shapes, such as hair or fine lines.

Using a Registration Frame. To make mattes, you will also need an 8 × 10 Condit Mask Registration Frame. This is a removable glass contact frame with two small registration pins for align-

Rubylith is a thin, red-colored material that is used to create mattes in special-effects work. It has one side that adheres to any surface. The rubylith is placed over the shape to be matted, and is then cut with a sharp blade all around the shape. When the surrounding rubylith is pulled away, you have a solid red matte of the exact shape of your subject.

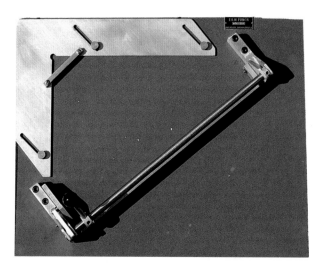

The Condit mask registration frame enables you to punch-register your transparencies and artwork so that they will be perfectly mounted at each stage of your copy work. Frames are available in a range of sizes to fit formats from 35mm to 8 × 10.

ing the litho material. A Condit 35mm to 5 × 7 film punch (or 8 × 10 if you shoot larger work) is also needed to pre-punch holes for use in registration. These are similar in use to an ordinary paper punch.

Preparations and Setting Up. In addition to your workstation, you will be using a light table and a second pin-registration bar epoxied to its edge. This pin bar will be identical to the one on your copystand, but the light table is where you will mount your mattes, transparencies, and other artwork onto acetate cels. These cels will be pre-punched for perfect alignment of all elements of your image. It is essential for all your work areas to be uncluttered, clean, and dust-free. My favorite work surface is white Formica because it makes dirt easy to spot, and is easy to keep clean after a project is finished. Whatever your materials, be neat. Photo compositing is also best done in an area where all incoming air vents are filtered properly.

Mounting Mattes, Transparencies, and Art. Before starting your copystand work, and matte making, there are some things you should do in preparation for clean, efficient work:

- Always watch for dust! It can get trapped between your litho film and your acetate. Antistatic cleaners, such as Dust-Off, can remove dust before it becomes a problem. Always start your mounting with clean materials.
- Mount the matte first. When preparing your work for mounting, always position your background art/transparency first. Next, remove that cel and mount each matte separately onto acetate cels. Finally, remove your mattes and mount any other art or transparency needed for the final image.
- Tape your mattes securely. When you tape a matte to its acetate cel, use only one layer of transparent tape all the way around the edges. This will guarantee an even surface and prevent distortion when you make a photo composite on the copystand.
- Combine mattes whenever possible. By contact printing several mattes onto one piece of litho film, you not only reduce dust, but also improve your chances for photocompositing a perfectly registered matte.
- Mask light leaks on acetate cels. When you shoot artwork or a transparency mounted on an acetate cel or copystand, you need to mask parts of the acetate where unwanted light shows through. The best material for masking acetate cels is black construction paper. Cut a piece large enough to cover the entire cel area.

Use a pencil to rough in the shape of the image mounted on the cel, and then cut out this shape with an X-acto blade. Tape the paper frame on the cel. If there are still some tiny areas leaking light, use black photo tape to cover them.

CREATING AND COMPOSITING THE MATTE

With a cube and textured background, you can create a matte of the cube and see the process of photo compositing in detail.

To composite the two images, you first need to photograph the cube against black seamless, or black velvet. Both provide a great deal of contrast and will absorb the light and make the cube stand out clearly in the transparency. Next, photograph the textured background. You now have the two elements of the final image. (If you lay one piece of film on top of the other, diagram A, at right, you can easily see how the texture shows through the image of the cube.)

Using the Condit punch, punch two holes in the margin of your transparency of the cube, outside the image area. Then, position this cube transparency on the pins of the Condit Mask Registration Frame. Now you are ready to create the matte. In your darkroom, using a red safe light, punch register an *unexposed* piece of litho film the same way you punched your cube transparency. Next, place it (emulsion side to emulsion side) over the cube transparency on the same registration pins. Close the contact frame and expose the litho film. Develop your film. You will now have a clear picture of film containing a solid black image of the cube (C). This is your matte of the cube.

Using your light table pin-registration bar, mount both the matte of the cube, and the transparency of the cube (B), on *separate* acetate cels that have been punch-registered. On a third cel, mount the transparency of the textured background. Now you are ready to composite the cube and the textured surface together.

First, place the matte of the cube on the pins of the copystand, then place the textured transparency on top of the matte. Make your first exposure using dupe film. Remove the two pieces of art and place the transparency of the cube on the copystand. Make another exposure on the *same* piece of dupe film. When you process the film, the final image will show a cube against a textured background (D).

Creating a Matte With Rubylith. If you want to make the final image of the cube and background described here using rubylith instead of litho film, follow this procedure:

Textured background before compositing.

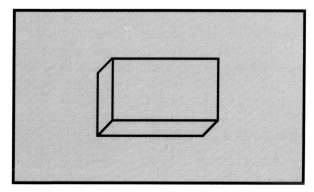

(A) Double exposure of cube and textured background. Without creating a matte to hold back the shape of the cube, both cube and background would combine in the same image.

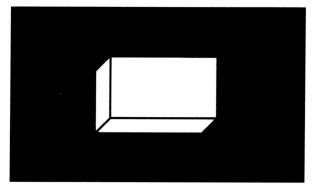

(B) Before the matte is created the cube is photographed against a black background.

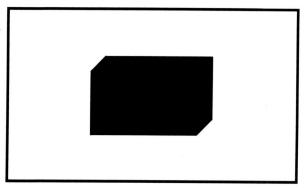

(C) The matte is an exact silhouette of the cube and will prevent light from exposing through this area.

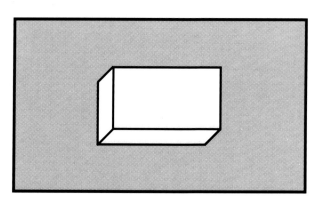

(D) The final image incorporates the cube and the background without the problem of both shapes showing through together.

Begin by punch-registering the transparency and a same-size sheet of clear (positive) litho film with your Condit punch. Using the Condit registration pins, sandwich the transparency and litho together. Be sure the transparency is facing up and the litho is on top of the transparency.

Cover the litho film with rubylith material, making sure the sticky side is down. With the aid of your lightbox, use a blade to cut around the entire perimeter of the cube shape as carefully as possible. Remove all surrounding rubylith. You should now have a red shape of the cube.

Flip the litho over so that the transparency is on top. Using a loupe, make sure the rubylith covers the entire shape of the cube, yet does not bleed out of the edges. If it does, try to patch it with small pieces of the ruby. When you are satisfied with it, contact this litho onto another sheet of litho film. This will produce a window of the cube shape. Contact the litho again and you will have a matte of the cube.

Always make sure that your mattes, whether of litho or of rubylith, are very clean and the edges are exactly shaped. When photographing images to be composited later, it is critical to keep a few basic rules in mind. If you are photographing something that is dark in tonal value, use a light background of seamless. Conversely, if your subject is light, use a black background. If your subject has several values or combines dark and light values, the predominant value should determine the background to shoot against. When part of your image around the perimeter is the same value as the background, you will have to patch it using an opposite color strip around that edge. In preparing photographed transparencies for use in making mattes, you want to make sure your image is as delineated from its background as possible. If the original photograph is one you have not taken, it may include a great deal of surrounding "stuff" you will want to mask out. The goal is to start with original art that is as clear as possible before you make your first generation mattes. You should always examine your mattes carefully with a loupe, to make sure you can go back and repair any edges or outlines that need to be masked with rubylith or opaqued.

MAKING MATTES FOR COMPLEX IMAGES

Occasionally you may encounter a transparency that has fine lines or shapes around its perimeter, an area that cannot be masked or painted in. For example, suppose you have an image of a light tonal value, and a small area of it, which I will call Part A, is dark along one edge.

As previously described, you should place a piece of white tape around the border of Part A to separate it from the black background (diagram A). Now you can photograph the object.

Punch register several sheets of unexposed litho film, using your Condit punch. Make a contact litho of your transparency. I will call this litho the positive—its background is transparent except for the small strip of black surrounding the transparent Part A. You will want to use black opaque on the non-emulsion side to paint in the patches in the lower part of the image that did not go completely black when you developed the litho.

Make a contact of the retouched positive litho (emulsion to emulsion). This will produce a negative litho (diagram B, at far right). Part A has gone black and is only separated from the background by a small strip of clear area. On this negative litho, carefully remove *all* the black, *except* Part A, by wetting the emulsion side and gently scraping it with the dull edge of an X-Acto knife (diagram C).

Using the Condit registration pins at your light table, place the negative litho (diagram D) on it, *emulsion side up*, with the pins through the punched holes of the litho. Next, put a tiny drop of glue on the dark part of the negative litho. Using the registration pins as a guide, place the positive litho (diagram B), *emulsion side down*, on the negative litho.

Contact this sandwich twice to clean up the background area. This final litho will be your matte (diagram E). When you contact print a matte onto litho film you create a window (diagram F), a transparent area which is the same shape of the black matte. Windows can be used to isolate anything unnecessary in the background; it is another type of masking device and is quite accurate, since it is created by the exact shape of the main object in your original.

MAKING THE FINAL COMPOSITE

After you have mounted your transparencies, mattes, and any windows, and you have checked to see that they register accurately with each other, you are ready to shoot the final composite of all these materials, using dupe film. At the copystand workstation, make sure you have each piece of artwork you will need. The sequence of stacking the acetate cels (which will have the separate art or transparency elements already mounted on them) is critical to successful compositing methods.

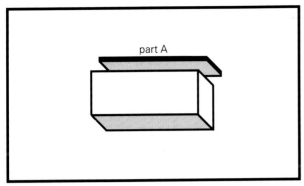

Original art showing area to be masked (Part A), prior to photographing it.

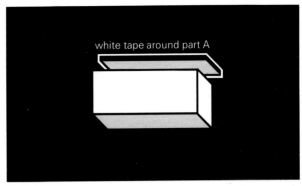

(A) Art shown against black background. White tape is used to outline an edge on the area around Part A.

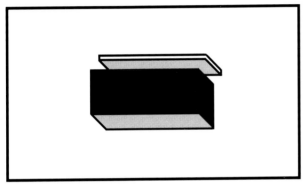

(B) Contact print of transparency on litho film. This is the positive litho.

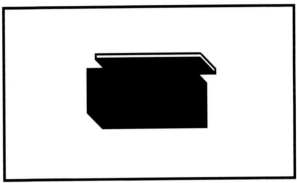

(C) By contacting the opaqued litho onto another sheet of litho you produce a positive litho.

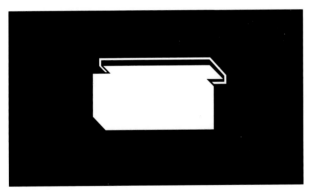

(D) Negative litho of artwork indicating area of Part A opaqued in black.

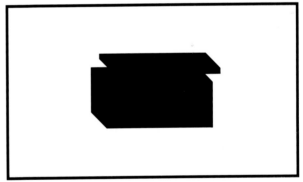

(E) Matte of complete artwork including all masked areas of original transparency.

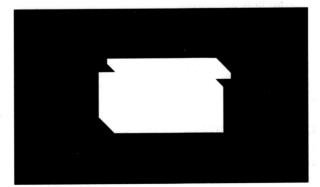

(F) Making a contact of the matte onto litho film produces the final window.

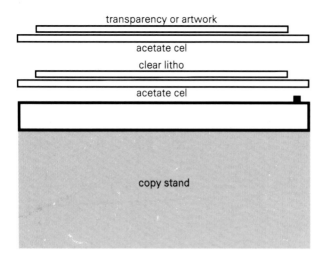

transparency or artwork

acetate cel

clear litho

acetate cel

copy stand

The order in which you mount and position materials on the work surface is crucial to registration and focus. Place the litho mounted on acetate down first, then the most important transparency (or artwork) next. At this time, focus the lens and keep it at this focus throughout the remainder of the process. Always make sure that an acetate cel with a clear litho on it is always positioned on the art beneath it.

An important rule of thumb is that each matte must be photographed at the same level and focus on the copystand as the transparency corresponding to that matte. Here is the sequence for preparing your mounted work:

• Place a clear litho, mounted on an acetate cel, onto the copystand.
• Position the most important transparency in the composite (the main subject) on the copystand next. *Focus the lens*, and make your exposure. *Do not touch the focus again throughout the rest of the exposures.* Remove the transparency.
• One by one, *position, expose,* and *remove* the remaining elements. Be sure that a clear acetate cel with a clear litho sheet always fills the level underneath each element.
• Remove the clear litho.
• Replace the clear litho with the mounted matte. Place your background art/transparency on the copystand. Make your final exposure.

NON-MATTE PROCESSES OF EXPOSURE

All special effects images are a result of making multiple exposures. Many of them require the matte-making processes described previously, but can also be made without the use of mattes or window masks to composite the final image. The simplest version of this is a sandwich composite of one or more images.

The important point to consider in using non-matte multiple exposures is carefully pre-visualizing the way individual elements of a composition will appear in the finished piece. Comps are essential during this preliminary process. You need to know both the light and dark tonal values of the subject, and where these tones will (or must not) overlap in the composite. The general rule for shooting multiple exposures without using mattes is to photograph the original objects against a dark background (or a light background if the object is dark to begin with). Try to keep the individual images separated from the background.

The Davila illustration on page 59 is an excellent example of a clean, well-executed design idea using this method. The final image incorporates the method of double-exposing the closeup flower and the vase onto one piece of film.

Using a Cropping Guide. When you prepare your comp or sketch of your idea, you want to position all your elements exactly in your viewfinder or groundglass. A cropping guide is an excellent tool to help you position the elements in your picture frame and can be purchased at any photo store. The sliding guide gives the crop marks for an 8 × 10 format. Here is how to use the cropping guide:

• Place the guide in its largest frame position and mark the cropping on a sheet of paper. Now you can draw your comp within these crop marks.
• Make a positive litho (black lines on a clear background) of your comp drawing, reduced and shot onto litho film to fit the format size you are working with.
• Place the litho on the back of your viewfinder/groundglass and use it as a guide as each separate element is photographed.

Another handy tool (if your 35mm camera has removable viewfinder screens) is the gridline screen. On this you can draw a copy of the screen grid and make photocopies, thus enabling you to line up particular elements in the viewfinder exactly.

THE ONE-CAMERA METHOD OF MULTIPLE EXPOSURES

Making multiple exposures in one camera is the simplest method, and the one used most often. First of all, because there is no matte to keep one image from overlapping with another, the area at which two images join becomes the sum of their respective exposures. This area will frequently appear lighter than the rest of the image. With the one-camera method, muddy backgrounds, loss of detail and contrast, can be

avoided only if you photograph your elements against a black background. Black absorbs all light and evens all tones.

The other rule to remember is to try to keep the number of exposures down to two or three. The reason is simple: the frame can only hold so many images of any size before they begin to overlap and create a washed-out appearance in the final image.

You can use this formula: If you have two images, underexpose by one *f*-stop or double the ISO; if you have three images, underexpose by two *f*/stops or triple the ISO. For example, let's say that the proper exposure for a certain image is *f*/8; you are planning on overlapping this image with another. You would expose the first image at *f*/11. If the second image had a proper exposure of *f*/5.6, you would expose at *f*/8.

MULTIPLE EXPOSURES
INCLUDING BACKLIT ARTWORK

The most exciting method of making multiple exposures involves exposing backlit graphics onto an image you have previously created or photographed. This way allows you to combine many different effects in the manner I described earlier. In the following chapter I will show you how to create some of these effects, such as glows, star fields, neon, and background gradations and blends.

When you experimented with these, try to think up other ways that you might incorporate more than one element in the finished piece. Each backlit graphic, whether created with an airbrush, drawn on acetate, or masked using different materials, can be combined with *any* photograph. You will also see how I have created some special sets in my own studio for particular projects. Remember, anything you can draw or photograph can be a part of your final image. Your imagination is your only limit.

At this point, it would be a good idea to go back over this chapter for a review of the basic matte and non-matte processes of making exposures. Once you feel you understand them, you can go on to creating some of the effects described in the next chapter.

THE MULTIPLE-CAMERA METHOD
OF MULTIPLE EXPOSURES

This is a very popular method of creating multiple exposures. Professional photographers like to use it because it gives both the art director and the client the least amount of worry and surprise about how the finished piece is going to look. The method also enables the photographer to retain complete control over every step.

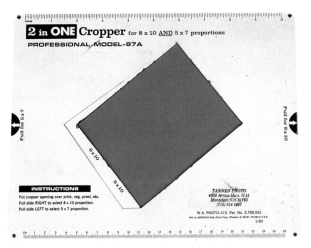

The cropping guide is a handy tool to help you position all elements in a design and comp. The format is adjustable from 35mm to 8 × 10.

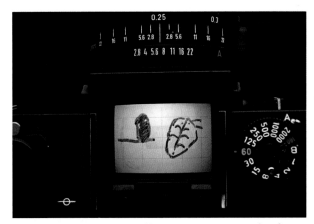

If your camera has a gridline screen you can sketch elements of your design directly on the surface of the grid. This will aid in the sizing and placement of the separate elements as they are photographed and combined in an image.

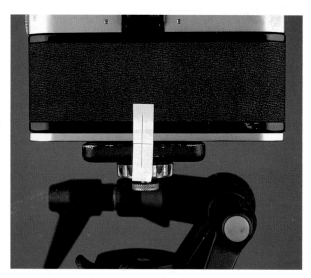

To transfer a camera from more than one tripod during a multiple exposure, first draw a thin line on a strip of white tape, cut the tape in half, and then position one half on the camera back and one half on the tripod.

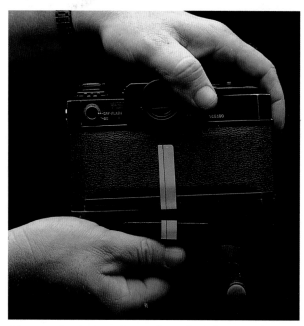

Line up the two marks on the strips of tape and you will be able to align the cameras in exact position to the tripods every time.

Before any exposure is made on film, take a Polaroid of each element of the exposure, using exactly the same camera position and lighting you intend on using in the final exposure. This allows you to make any corrections before you proceed to the next step.

To begin a multiple-camera project, you must again develop and comp an idea of the final desired image. Ideally, you will have one camera for each exposure. Because this involves rotating your film from one camera to another, large-format cameras that have sheet-film holders are the most convenient to use: you can just set each holder directly into position for the next exposure. Some medium-format cameras, such as the Hasselblad, Mamiya, and Bronica models, have removable backs that also enable you to do this. But if you have only a 35mm camera, you can make sure your individual exposures are in exact position by simply transferring the camera from one tripod to another. Here's a simple trick to help you line up the cameras each time:

- Place the camera on a tripod and crop the shot as you wish in the viewfinder.
- Draw a fine, straight line across the diameter of a gummed label, and then cut the label in half perpendicular to the line.
- Stick one half of the label on the camera back and the other half on the tripod base, and line them up. Now remove the camera with the half of its label and secure it to the next tripod.
- Crop your next image.
- Take half of another label with an identical straight line drawn on it, and position it as you did the first. Continue this process with as many tripods as necessary.

The image at right is a graphic example of the combination of a photograph and backlit graphics in a multiple exposure. Using the multiple-camera method, each of the elements was precisely positioned and then composited for the final image.

CREATING
BACKLIT SPECIAL EFFECTS

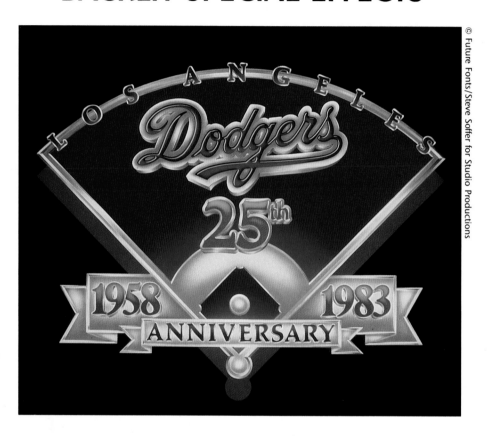

© Future Fonts/Steve Soffer for Studio Productions

ALL BACKLIT GRAPHICS are created by illuminating a piece of artwork, usually a litho you have made from a drawing. But the art of the technique lies in your idea of the piece to begin with. Most special effects begin at the drawing board, where comps are created and the idea of the effect takes shape. Do you want to simulate a galaxy filled with stars? Perhaps a sunny horizon bleeding into a dark evening? Or, you might want to illustrate the effect of neon or of lightning bolts streaking across the image. Any one of these effects can be realized. And when they are combined with each other in a single image, your final art will be a striking example of the possibilities of backlit special effects.

The following section will teach you how to create these various effects. You will find many of them used in my step-by-step examples on pages 54–101. Most are very simple to achieve, and the most difficult needs only some extra prep time and a little practice.

Using the materials discussed in Chapter 2, you will soon be on your way to creating your own special effects. Do not feel limited to just repeating the ones here—design your own—all you need to begin is an idea and a pencil.

First, here are some tips for preparation:
- Always start with a comp. Sketch your ideas on paper and keep experimenting until you have a desired shape or effect. When you have, determine the final size you plan to work in: for example, 35mm, 4 × 5, 8 × 10. Then make a final comp to that size, indicating the various position of each element in your image.
- Scale your drawing. Make sure you work at least 100 percent larger than the final image format you plan to work in. When you reduce the artwork, imperfections will not be noticeable in the finished artwork.

- Make a stat of the drawing. Always work at 100 percent (same size as original) when sizing the stat. This permits you to make clean retouching of any art. You can then reduce your finished art to the exact size of your final image.
- Photograph the stat onto litho film. The litho film, whether negative or positive, will be the material you backlight. It must always be punch-registered to the specific format size you want work in.
- Mount the litho on acetate. The acetate cel will ensure accuracy when registering your artwork on your workstation.
- Make color and exposure tests. These will allow you to see the results of various color filters and diffusion effects before you're finished.
- Record all information. Each project you work on will always add to a file for future reference on how an effect was created.

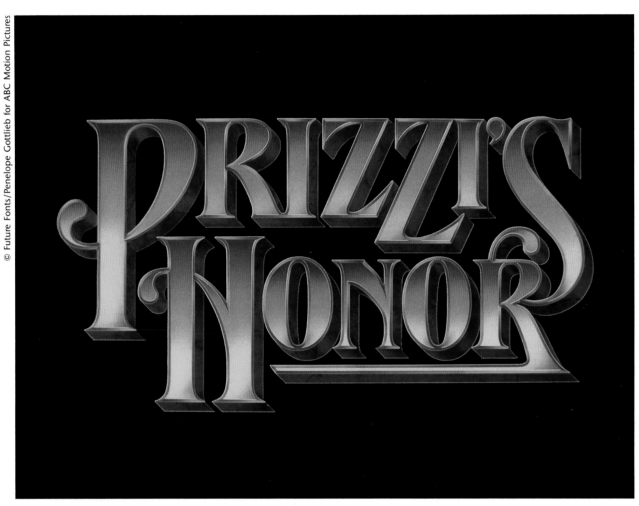

Type design is one of the most creative applications of backlit graphics techniques. The two examples here, for the Brooklyn Dodgers, and the film "Prizzi's Honor," were created solely with these effects.

GLINTS AND STARFIELDS

If you want to create a gleam in someone's eye, a shimmer in a piece of metal, or a night sky filled with stars, your basic technique will involve simply drawing tiny dots of ink on Durolene. Vary the size and shape for different effects.

1. Using a clean sheet of Durolene, ink in the number and size of the dots that you want. If you are making a precise glint, make sure you draw it in the exact position it will appear mounted in the final image. This is done by placing the Durolene over the art/transparency on your light table.

2. Shoot the Durolene drawing onto litho film.

3. Mount the litho film to a clean acetate cel, and place it on the workstation to backlight it.

4. For soft-focus effects experiment with diffusion materials such as Flexiglas and Plexiglas. Start with only a sheet or two of either material, then add more for a more diffused effect. (You can also try to use a smear of petroleum jelly to get a soft effect).

5. For a cloud effect, add one or more soft-focus or fog filters on your copy lens, and photograph through that. Or try using a combination of these diffusion materials and see which is best for the image you have in mind.

6. To produce a glint (sharp beams of light originating from one light source), place a "starburst" filter over the lens. These come in various numbered ray patterns, such as 4, 6, or 8 rays, depending on the effect you want.

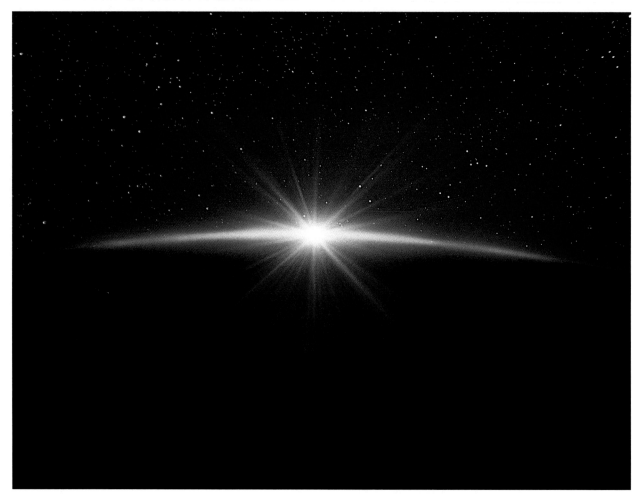

Glints and starfields are two dramatic uses for background special effects. The example above, and at right, were created by drawing an array of dots directly on Durolene. Diffusion material was also used for added soft-focus effects.

GRIDS AND LINE ART

The challenge in creating backlit special-effects grids or lines is in rendering a drawing with accurate perspective. If you cannot do this by hand, use a perspective grid, available in art supply stores, to trace over. You can also consult books of maps or architectural manuals, which may include illustrations of grids and lines. Keep a file of "scrap" art for future reference.

1. Suppose you want to create a laser-ray line effect. First, make a line drawing. Make a 16 × 20 stat of your art. Clean up any imperfections on it using white opaque and ink pen.
2. Photograph the stat onto 8 × 10 litho film, and mount it on an acetate cel.
3. At the workstation, make exposure and color tests. An *f*-stop such as *f*/3.5 or *f*/2 will produce a wide glow, while *f*/11 or *f*/16 produce a much more narrow glow effect.

4. Using the diffusion materials you have decided on by the test, make an exposure.
5. Using a pink filter make an exposure.
6. Without touching the litho artwork, remove the diffusion material from it, and replace that with a single sheet of Flexiglas.
7. Make a double exposure through a deep yellow filter. Your result will be a yellow laser-like line, with a soft pink glow. The yellow burns through the pink, thereby allowing the colors to be placed on top of one another. Some colors will blend together, creating a completely new color. Exposure always plays a role in mixing and blending colors: the longer the exposure time, the brighter the color; the less the exposure time, the subtler the color will be (and therefore more likely that the color will blend more easily).

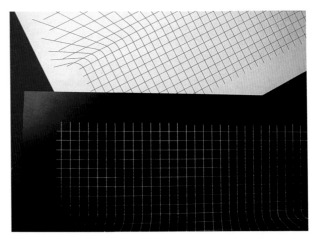

Perspective grids are available in pre-printed sheets at most art supply stores. They can be photographed directly, or traced over to produce the various grid patterns you want to use in your design.

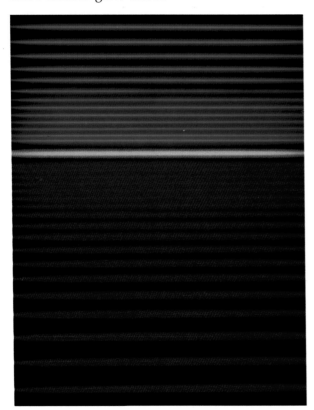

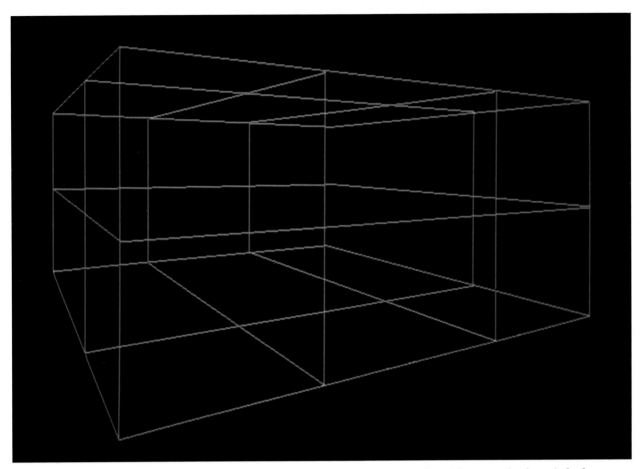

Grids and lines can also be created on the computer for a three-dimensional effect. The example above is broken down into twelve individual boxes within the single box.

COLOR GRADATIONS AND BLENDS

For overall backgrounds, backlit gradations lend an excellent field on which to combine other elements. These smooth effects resemble airbrushing and offer you a similar control over color. On film, you can make colors blend from dark to light over a very narrow area, or over the whole expanse of the background. You can also blend two colors to make a third, or confine a gradation to a specific area in the image.

Here is an example of how to make the simplest kind of color gradation—one color changing in value from dark to light. No lithos are required for this effect.

1. Using black construction paper, cover up all the glass work surface on your copystand, leaving a strip one-inch wide at the center point where you want the horizon line to begin.

2. Place a piece of ¼-⅛-inch-thick Plexiglas over the exposed glass strip, and then put a colored filter on the copy lens.

3. Come in very tight on the art with your copy camera, and crop the shot any way you wish. For the smoothest transition in value, throw your copy lens out of focus. By moving the camera in and around the glowing line, you will be able to select the degree of gradation that you want, and the glow will overlap, going from dark to light.

4. Make an exposure and examine the results.

5. For color blends, follow the same procedure, except make a three-inch strip running down the center. Cut a one-inch strip of construction paper and place it in the center of the three-inch strip area. Now you have two one-inch areas separated by a one-inch black area. This black area is where the two colors will blend. First, mask off one strip with the construction paper, backlight the glass and expose through a colored filter, change filter colors, and mask off the second strip area. Expose this second strip through another colored filter. When blending colors, make sure your area is large enough to accommodate the number of colors and width of the blend you want to create. Each color in the blend must be exposed separately while masking off the second strip.

Color gradations and blends are created by placing black construction paper over specific areas of your design, and then backlighting it with colored gels. Varying the size of the black paper will give a variety of lines or gradations.

HORIZON GLOWS

A horizon glow is simply a controlled gradation. The lines on your field chart are your guide for determining where you position the horizon line in the final image.

1. At your lightbox, position the field chart on the pin-registration bar, and place a clean acetate cel on top of it.
2. Tape black construction paper on the cel, covering the area beneath the horizon line you have chosen. Mark the field chart line number for reference.
3. Line up the edges of the paper and the acetate cel with the rules of the field chart.
4. Position this acetate cel mask on the registration pins on your copystand.
5. Lay a sheet of diffusion material on top.
6. Put a color filter on your camera lens and make your exposure tests.
7. If you want your upper "sky" area to fade to black, place a small black card over part of the lens. By looking through the viewfinder, you will see where to position the card to achieve the proper falloff to a gradation of black. Remember to stop down your lens to the exposure you'll be using, because the gradation will appear different at f/5.6 than f/16. For a "feathered" effect, before exposure, put a piece of construction paper over part of the Plexiglas inside your lightbox; by moving the paper around, you will get the effect.

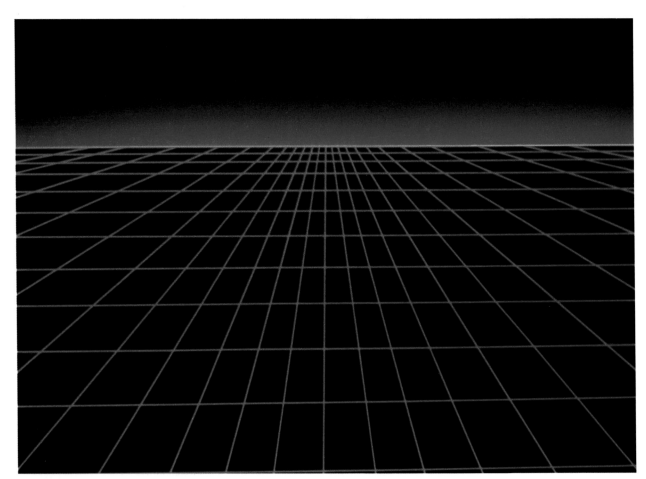

Horizon glows are created by placing a sheet of black construction paper over the area you want your horizon line to begin. Use the field chart to help you line it up evenly. The area that is not covered by the paper will be the glow.

HORIZON EXPLOSION

This spinoff of the straight horizon glow is a dynamic effect, and it requires only one piece of artwork. I call this art a "pregnant" line, because it is thicker in the middle than at the ends.

1. First practice drawing a version of the line as a comp. When you have achieved the desired size and shape, ink in a drawing on Durolene.
2. Make a negative litho of the artwork, and mount it on an acetate cel.
3. Place the litho on your copyboard.
4. Lay a few sheets of diffusion material on top. It is difficult to determine in advance the amount of diffusion, since it depends on both the size of the artwork and the amount of explosion effect you want. The general rule is to use about half of what looks right to your eye. This is because part of the effect of the explosion comes from overexposing the film.

5. The final step is to run an exposure test using a color filter of your choice. If the explosion effect looks great, but the color is washed out, try adding more diffusion material and cut back on the exposure time. Avoid using dark or cool colors in this effect: they do not work as well as the warm reds and yellows.

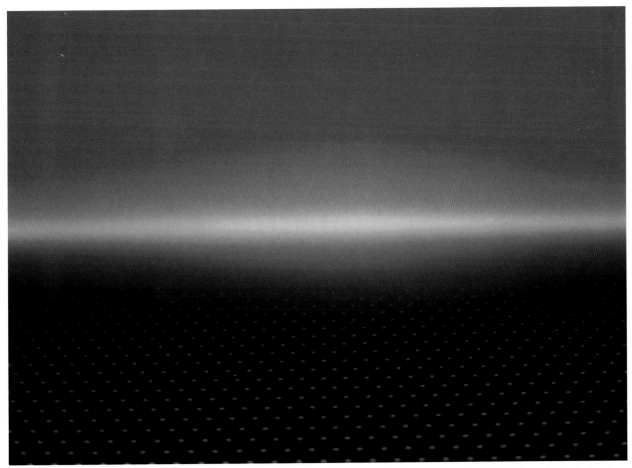

An added effect to a horizon glow, the horizon explosion is created by drawing a shape on the litho material that is rounded in the middle of the horizon line.

LIGHTNING AND ELECTRICAL BOLTS

The first step in creating these effects is to do a little research. Collect as much scrap art from magazines or stock art books as you can. Your local art supply store, or your librarian, will be a good source of finding these publications. Use the materials to practice drawing all kinds of lightning bolts and electrical charges. When you are satisfied with your efforts, you can make the art for your own images.

1. Ink in your desired effect on a clean sheet of Durolene material.

2. Make a positive *and* a negative litho of the drawing. They must be punch-registered to ensure that they will line up perfectly when placed on top of the copystand.

3. Mount each of the lithos on a separate acetate cel, in the following manner: Lay an acetate cel over the pin bar on your lightbox, placing your *positive* litho on top of the cel. Tape it down on the cel with clear adhesive tape.

4. Remove the positive litho/acetate cel.

5. Mark a small square on the cel, corresponding to each registration pinhole in the litho.

6. Cut out a square of acetate around each of these two marks. Now there are two small square holes in the acetate just big enough for the registration pins to penetrate.

7. Place another clear cel on the pin bar and tape its edges to the lightbox. Lay the positive litho you just mounted on top of this second cel, and slide your registration pins one at a time under the positive litho and through the holes in the acetate so that the pins are secured in the registration holes.

8. To set the pins for perfect registration of the negative *litho*, first lift up the positive litho and place one small drop of glue on the bottom of each registration pin.

9. Slowly and carefully lower the positive litho and pins unit down onto the cel beneath it.

10. Place a piece of glass over this, being careful not to disturb the pins. Allow them to set firmly onto the second cel. When they have, carefully remove the positive litho to a clean, dust-free surface.

11. Next, you must prepare to mount your negative litho on a pre-punched acetate cel. Lay a new cel over the pin bar on the lightbox.

12. Cut two small openings for the glued pins to go through, so this new cel can lie flat on the lightbox surface.

13. Place the negative litho over the glued pins and down onto the cel.

14. With everything in position, tape the negative litho to the new cel, and take the negative litho acetate cel off the lightbox.

15. Remove the acetate cel with the pins glued to it, and put it aside. Now you are ready to shoot the effect.

16. First make a test shot, using the negative litho without any filters or diffusion. Make the test exposures. The best exposure will be used to create the lightning effect.

17. When you have chosen an exposure for use, lay a sheet of Flexiglas on top of the negative litho, and put the positive litho on top. This will bathe the lightning bolt in a glow.

18. Shoot another test exposure using the sandwiched lithos. This will be used as the glow exposure in the image.

19. When you have determined your desired exposure for the separate elements, combine the images by double-exposing them.

Lightning effects can be incorporated from a wide range of sources. Try to collect research images of lightning, from magazines and other publications, and practice tracing them. You can then draw them directly onto your film and composite them in the final design.

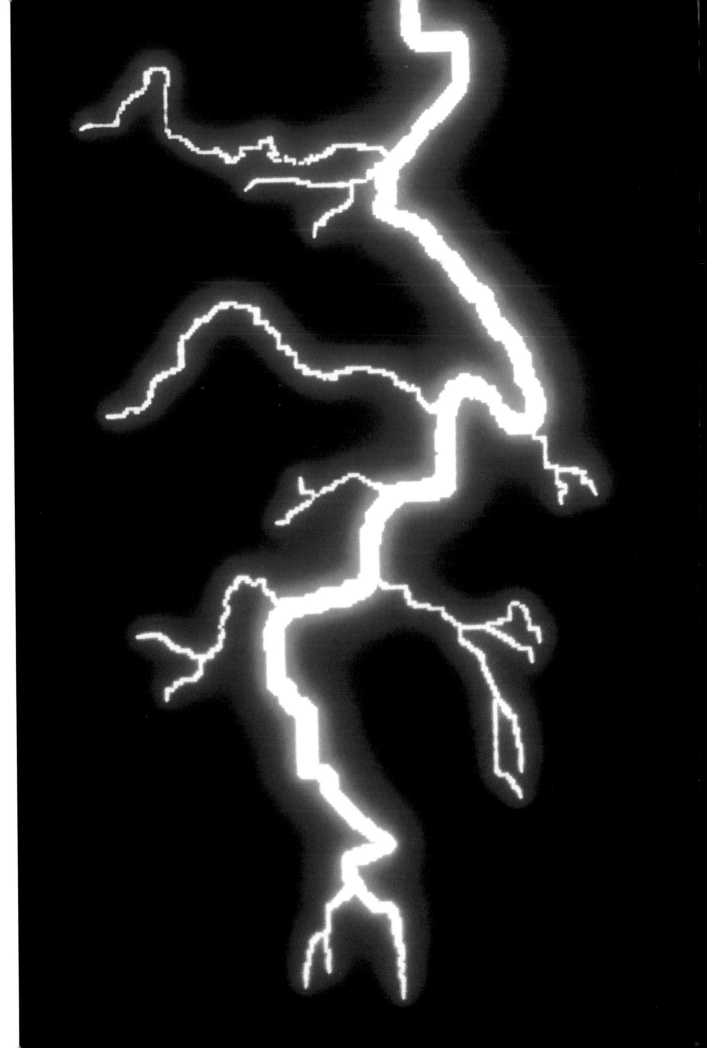

NEON

Creating neon effects requires two separate pieces of artwork: the neon tube shape and a highlight on the tube. The highlight gives the impression of roundedness to the tube.

1. First, determine how thick you want your neon tube to be. Once you have decided its dimensions, draw the shape of the tube. Remember to make the closed ends of the tube round, not squared off.

2. Ink in your final drawing on Durolene. Now you are ready to create the highlights.

3. Place a clean sheet of Durolene on top of the drawing of the tube shape and tape the two together lengthwise. Lay this on your light table so that the tube shows through.

4. Using the drawing of the tube as a guide, pencil in where you want the highlights to appear on the tube, on the top paper.

5. Turn off the light table, and ink in the highlights where indicated on the comp.

6. You will need to make three lithos: a positive and a negative of the tube shape, and a negative only of the highlights.

7. Mount all three lithos on separate, prepunched acetate cels.

8. At your workstation, photograph the negative litho of the tube, using colored filters of your choice. You can also add a soft-focus filter to soften the edges slightly. I recommend doing an exposure test series, from which you can pick the best image.

9. To create a glow, lay the negative litho on the work surface first, then a single sheet of diffusion material, and then the positive litho.

10. For a color and exposure test, use a color filter lighter than the one you used to shoot the tube shape. If you use the lens wide open (i.e., $f/2.8$) the glow will be very broad and more pronounced. If you stop down ($f/16$ or more), the glow will be thinner.

11. To shoot the highlight art, you normally would not use a filter. If you choose to, also use a lighter color than the tube. The highlight must burn through the tube's color to be seen on film. A soft-focus filter can also be used for diffusion of the highlight.

12. The final exposure sequence would involve shooting the separate elements: first, expose the negative litho of the tube shape; second, shoot the glow of the tube by exposing the positive/negative litho sandwiched between a sheet of diffusion material; third, expose the highlight.

The original artwork for your neon effect should be drawn carefully; make sure the edges are rounded.

The neon effect is first inked in on Durolene, and the highlight areas are then traced over the acetate.

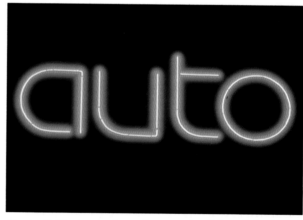

To create the neon glow, the negative litho of the image is diffused with a sheet of Flexiglass and then photographed. The highlight areas will burn through this.

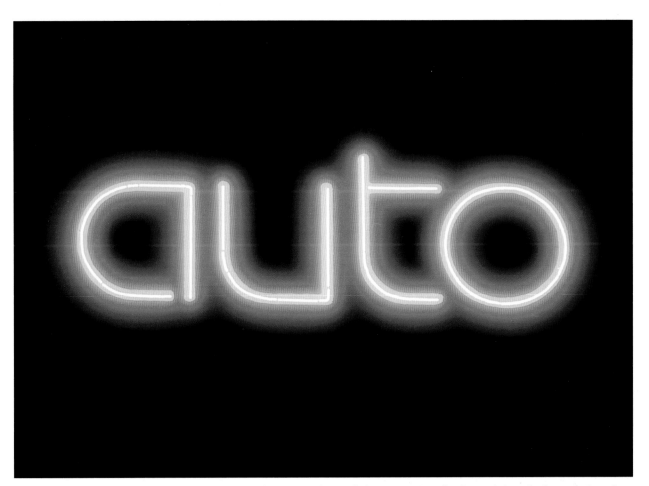

The completed special effect incorporates both the neon color and the highlights. In determining the best choice of colors try to use very strong pinks or reds, which are more realistic to actual neon signs. Remember to keep letters rounded on the ends to give the suggestion of the neon tube shape.

DROP SHADOWS

This effect is indispensable when you want to give a flat image the appearance of its floating above a surface in a three-dimensional perspective. The effect is produced by simply making a litho matte of the object you want to use in drop shadow. The matte is shifted slightly to one side, thus creating the shadow effect.

1. Make two mattes and one window of the object you want to shadow, using litho material.
2. Mount your transparency/artwork on an acetate cel in the desired position for your final composite.

3. Tape the litho window on top of the transparency, using the pin-registration holes in the transparency.
4. Mount one of the litho mattes on a prepunched acetate cel, in registration with the transparency. This will be your matte artwork.
5. Place an acetate cel on top of the mounted litho matte, and on top of this cel mount the second litho, shifting it slightly to one side. This will be the shadow. Label it as such.
6. When you composite the images, remember to keep the drop shadow litho on the copystand *throughout* the shoot, to produce a black shadow.

Drop shadow effects are quite easy to create. The effect is produced by shifting the negative litho matte of the object to the right or left. When the image is composited with the original transparency this area will show up as a black shadow outlining the shape.

AIRBRUSHING

An airbrush gun is a basic tool for most special-effects photographers. Beautiful, delicate shading and gradation can be achieved that would be difficult to obtain by hand. Ink or opaque color is placed in the holding cup. The trigger allows you to regulate the air pressure and the amount of paint sprayed. The distance from the actual surface being worked determines the area being covered: move in close and you can paint a small dot or line; move away from the surface and you can cover a much larger area.

To simulate the airbrush effect on transparency film, use acetate ink (made especially to adhere on acetate) on Durolene.

1. After you have created an airbrush drawing on Durolene, make a negative litho of it.
2. At your copystand, backlight this litho using diffusion material such as Plexiglas or Flexiglas. (Place a colored filter over your lens if you do not want white.)

Airbrush effects can also be used with line art, such as streak effects, to create the illusion of the streaks fading off into the distance.

1. Carefully place the mounted litho of the line art on your light table.
2. Cover the art with an acetate cel.
3. Using black opaque or ink, airbrush the area you want to fade off.

When shooting onto transparency film at your copystand, always place the airbrushed cel on the surface first, then a sheet of diffusion material, and the line art last. The diffusion material softens the airbrush art to give you a true airbrush rendering.

Airbrush effects are an excellent way to incorporate artwork in your special effects. You can create a wide range of lines, shadows, glows, and streaks. The airbrush technique produces smooth gradations of tones and is very easy to use on all drawing surfaces.

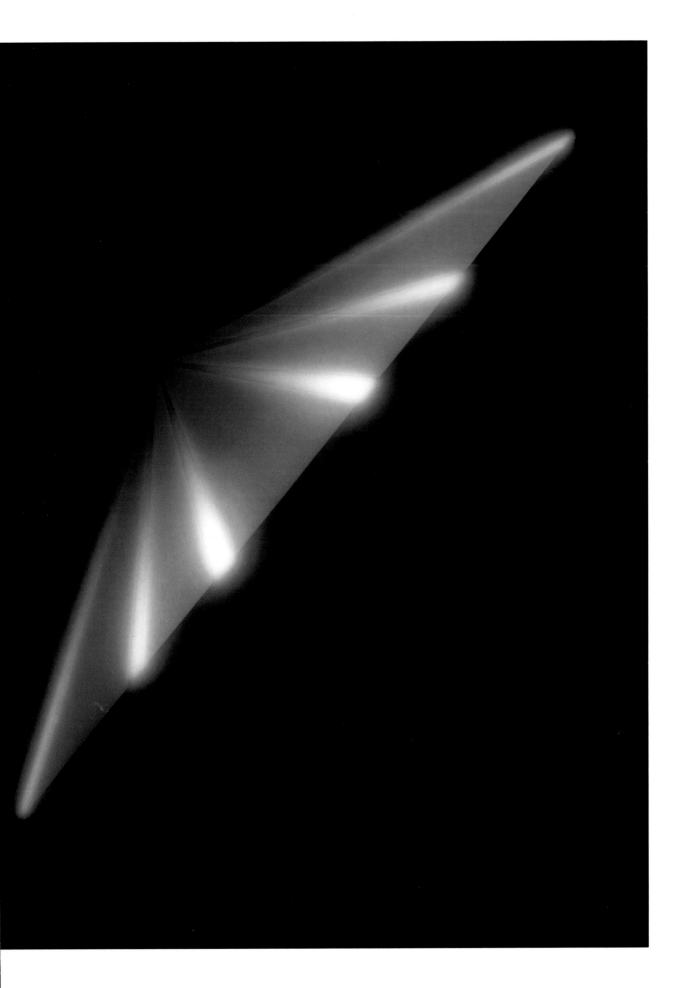

STREAKS

With a stationary camera, one of the simplest methods you can use to create the illusion of movement is with a streak filter. However, these filters can only create streaks in a straight line. They also blur part of the image itself. Another approach involves zooming in or out with a zoom lens. One of the best ways to create streaks is to use the airbrush technique.

1. Sketch the exact position and size of your streaks as you want them in the image.
2. Tape this sketch down onto your work surface and tape an acetate cel over it.
3. Using black acetate ink and the airbrush, spray over the tracing. Keep the edges of the streak soft, and the center solid and dark.
4. Contact the airbrushed acetate onto litho film. This will produce a black litho with clear areas.
5. Mount the litho onto an acetate cel. Make sure it is in the position you want for the final image.
6. Diffuse the streak artwork by placing a desired amount of Flexiglas over the litho.
7. Make your exposure, with or without the use of a color filter.

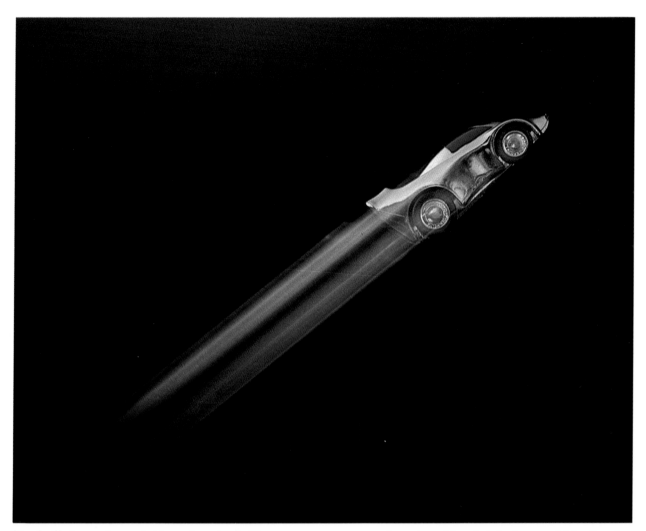

Streak effects can be created by using streak filters on your camera, or by using airbrush techniques, which allow for much greater flexibility in producing different shapes and sizes of a streak effect.

PRINT MONTAGE

A unique approach to compositing images is to montage individual components of enlarged prints onto a background image. What you must do carefully in this process is to make sure you have photographed the separate components to the exact perspective, and make sure that your lighting is even throughout the separate sets.

Airbrush technique can be very useful here, enabling you to create blends from one part of a montaged piece to another. It will also hide the edges of the cut artwork, so that the final image appears more convincing when reproduced.

1. After preparing and sizing your comp, photograph each component in proper perspective to your comp. Because you will be making prints, use an appropriate type of *negative film for C-prints, or transparency film for Cibachrome prints.* Only print glossy if you *don't* intend to do any airbrush retouching.
2. Have an 11 × 14 or 16 × 20 matte-finish (or glossy) C-print made of your subject background. This is the print on which you will montage the other elements.
3. Mount the background print on a sturdy sheet of mounting board.
4. Using an enlarger, project each image onto the background print. Make a tracing on paper for the printer to use as a guide. Have each element printed individually.
5. After you have your finished prints, cut around each shape carefully, using a sharp blade. Rub all the edges with a soft lead pencil to help camouflage the white edge where the print was cut.
6. Spray or dry mount all the elements to your background print.
7. Make an acetate overlay large enough to cover the entire surface of the artwork. Tape it over the image. If you have airbrush work you want to add, or retouching, do it directly on the surface of the acetate. *Never airbrush on the image itself;* if you make a mistake, you will have to make new original prints.
8. Have a professional lab make a finished copy of the montaged print. The copy negative will always be available to generate more prints or transparencies for future use.

For this promotional piece, I decided to have some fun illustrating how photo montage can be used for food advertising. I first made a comp of how I wanted the finished piece to look, carefully placing the individual elements. My neighbor's son was the perfect model; I dressed him in a baseball cap and jersey and positioned him at a table covered with a blue-checkered cloth. A baseball glove, bat, and ball were strategically arranged, using my comp to visualize where I would airbrush the mustard streaks. A red plate with a hot dog on it was added to the table. The background was a 12-foot roll of black seamless.

1. Using a 24mm lens on my 35mm camera, I photographed down on the table from a high perspective. I used Kodachrome 25 film for best resolution and fine grain. I made several exposures, developed the film, and chose the best.
2. I had an 11 × 14 Cibachrome print made of the transparency. Using a tissue overlay as a guide tracing, I sketched in where I wanted to place my objects and roughed in the size and perspective of each.
3. I photographed the individual objects, using a 35mm camera and Kodachrome 25 film: hot dog and bun (without mustard), both mustard dispensers, and the relish jar. All were shot against a black velvet background.
4. I had Cibachrome prints made of each object, sized for my 11 × 14 Cibachrome master. The lab used the tissue overlay as a guide for size.
5. From these prints, I cut each out with an X-Acto blade, then went around the edges of each cutout with a pencil to eliminate any white.
6. I pasted the individual cutouts onto the master Cibachrome print.
7. A clear acetate overlay was placed on the entire print; I then airbrushed in the mustard and relish directly on the acetate.
8. The finished montage was copied onto 8 × 10 transparency film.

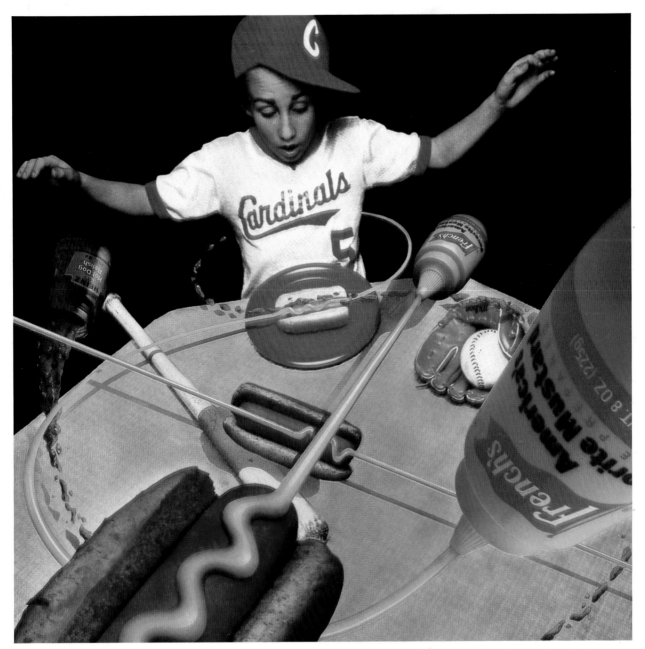

This print montage, for French's mustard, is an example of the creative application of the technique. In this image, the hot dog, mustard, and relish were individually photographed and then were montaged in combination with the background image and various airbrushed effects.

STEP-BY-STEP EXAMPLES IN APPLICATION

APPLICATION
OF SPECIAL EFFECTS TECHNIQUES

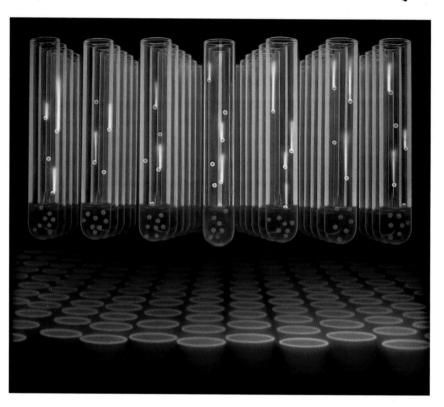

THIS SECTION is distilled from my experience in a special school in the real world of advertising—the school of hard knocks. Advertising photography is an unforgiving and pressured profession. Art directors and clients have a peculiar memory system—they only remember your last good job. More crushingly, they never forget a bad job, no matter how many great ones you do later.

This is one profession in which practicing on the job can quite often spell a short-lived career. Each job must be done seemingly effortlessly, and be brought in on time and on budget. Over the years, I have discovered that the most challenging images were not the ones I designed, but images created by people who knew nothing about special effects. Many of my more difficult projects were originally designed for illustration, not photography. Not knowing what was or was not possible gave the designers who hired me the freedom to demand solutions from me that pushed my imagination to new limits.

The examples of my advertising work that follow are the results of some of those challenges. I hope you will use them as a *source* to think about your own ideas for special-effects work.

Read the description and methods of how each image was created several times, so that you will have a clear understanding of the processes. Focus on understanding and visualizing the processes. Do not reproduce my exact images here; use the techniques described as a foundation for your unique ideas. Remember to always record your progress—note all exposures and shooting sequences—this information will be a useful reference for your future work. Save everything!

If you follow my step-by-step examples carefully, make sure you understand them, and then experiment on your own, I guarantee you will be successful. In creating these special effects, persistence, good record keeping, proper equipment, and your own experience and imagination are what matter most.

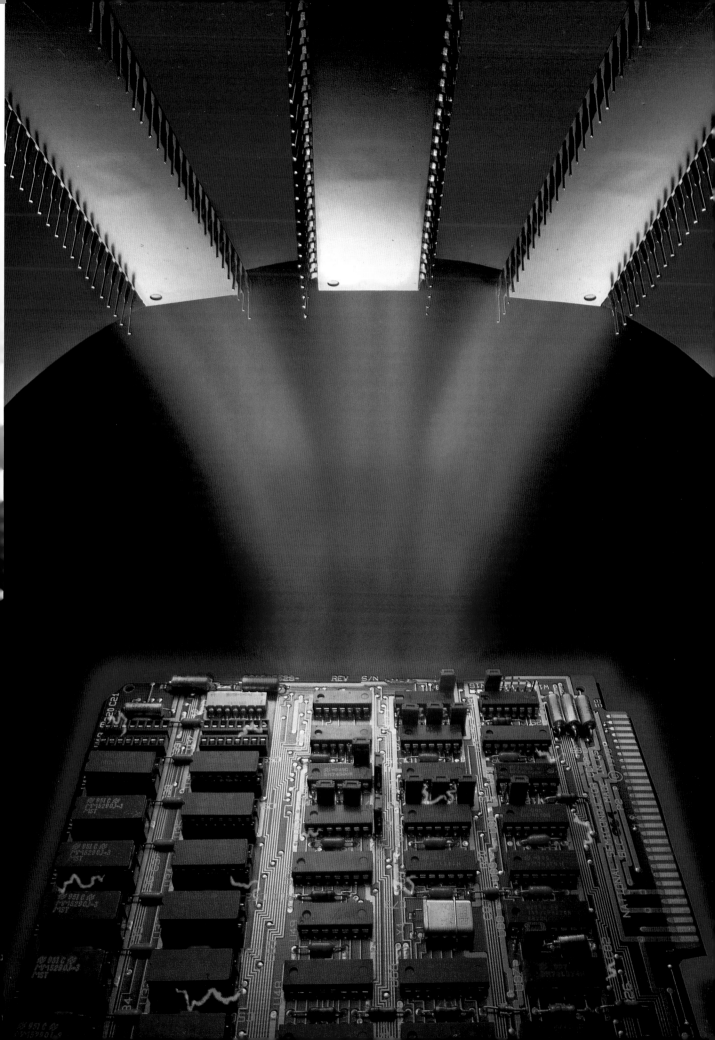

MULTIPLE EXPOSURE WITH BACKLIT GRAPHICS
CAMERA FORMAT: 8 × 10
CLIENT: QUANTEL

For this project, I first had a meeting with the client's art director. He explained to me how he wanted the final image to look, and gave me a comp that indicated where the various components were to go. Also shown on the comp were his color choices: a dark blue for the grid background, light blue for the earth shape, green for the outlined continents.

From this comp, I planned how many lithos and mattes I would need to make for the image: 1) a litho for the green continents, 2) a litho of the light blue earth, 3) a litho for the dark blue grid, and 4) a matte of the earth map. To prepare for this project, I did some library research, looking through various atlases for the particular map I wanted to reproduce in the final image. Finding the right one, I then made a photocopy of it to use later in the studio.

STEP-BY-STEP

1. On the photocopy of the map, I opaqued out any areas that needed cleaning up or that I did not want reproduced in the final image.

2. I had a high-contrast stat shot of this opaqued artwork, at 70 percent reduction, to fit my 8 × 10 copystand format.

3. To produce the grid background, I worked with a perspective drawing. I placed an 11 × 14 sheet of Durolene over this perspective drawing on my light table and inked in all the lines.
4. I had a stat made of this grid background, also shot at 70 percent reduction.
5. At my light table, I sandwiched the stat of the map with the stat of the background grid. This gave me a preview of the finished piece with all the elements in place.

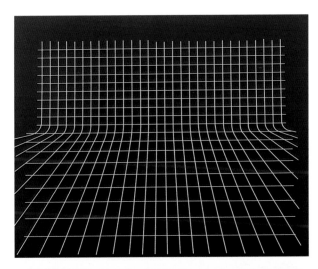

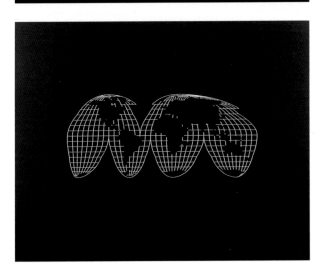

6. I made negative lithos of *each* stat, all of them shot at 100 percent.

7. I made one *extra* negative litho of the earth stat. I intended to use this for the green continents. On this litho I opaqued out everything *except* the shapes of the continents.

8. Using the extra litho of the earth, I opaqued out the continents. I would use this litho for the light blue grid.

9. I did not want the dark blue lines of the grid to burn through the earth shape on the final image; to prevent this, I painted out the earth stat in black.

10. I had a *positive* litho made of the blacked-out stat of the earth. This would be used as the matte for this component.

11. I separately mounted each component—the three negative lithos and one positive matte—on separate acetate cels to composite the final image. Next, I needed to create the colors for each.

12. I placed the negative litho of the continents on my workstation and then covered the litho with a sheet of Flexiglas diffusion material.

13. Using a green filter over my camera lens, I made my exposure.

14. I then positioned the earth litho on the work-station and covered it with a sheet of the Flex-iglas. Using a CC40B filter on my lens, I made my next exposure.

15. I then positioned the grid litho on the work-station, covered it with Flexiglas also, and made an exposure using a dark blue filter.

The final composite of the Quantel ad incorporates the grid, the earth shape, and the continents in a graphic and colorful representation.

TWO-PART MULTIPLE EXPOSURE, NO MATTES
CAMERA FORMAT: 4 × 5
CLIENT: DAVILA STUDIOS

The client, a manufacturer of window display art, wanted to promote a striking new piece of his work—a large vase and sculptured calla lilies. The flowers had such beautiful form and detail that he wanted to highlight one up close, and also show the vase and flowers as a set in the same image.

STEP-BY-STEP

First exposure, single flower:
1. I arranged the flower in the vase and the set was placed on a table.
2. I hung a drape of black velvet 3 to 4 feet behind the flower to obtain a completely dark background. I darkened my studio lights.
3. Using a small softbox for illumination I lit the flower, placing some fill light on particular areas with a white reflector.
4. Using a 4 × 5 view camera with a 210mm lens, I came in close on the flower and framed it to the far right on my camera groundglass.
5. I shot a few test Polaroids for composition and lighting checks. Determining my best shot, I made six exposures: two normal, two at ½-stop over, two at ½-stop under. I marked each film holder with the corresponding exposures so that I could refer to them later.
6. On my camera groundglass, I traced the exact position of this single flower, then cleared the set for the next image.

Second exposure, vase and flowers combined:
7. I covered my shooting area (in this case, my cove), with a 12-foot roll of black seamless paper.

8. I placed a stool 7 to 10 feet in front of this background, and covered the stool in black velvet and placed the vase and flowers on it in a pleasing arrangement.
9. A long, narrow piece of Foamcore had been previously painted to match the color of the vase; I taped this Foamcore to the arm of a C-stand clamp and placed it just below the vase's base. This gave the illusion that the vase was resting on a shelf.
10. Using a medium softbox, positioned overhead, I illuminated the set, being careful not to spill any light onto the black seamless paper in the background.
11. With my same camera and lens, I used the tracing of the first flower on my groundglass to help me now position the vase and shelf on the groundglass of my viewfinder.
12. After deciding on the best exposure, I picked up the holder marked "normal" and exposed both sheets.
13. I then opened up my f/stop setting by +½ stop, and using the holder marked "+½", exposed both sheets. Finally, I stopped down ½ stop from my normal exposure and, using the holder marked "−½", I made my last two exposures.

At my lab, I ran one of my "normal" sheets at normal development. I looked at that processed sheet, made a slight adjustment in development time, and then ran the other at normal development, plus one each of the +/− sheets. After making additional slight adjustments, I finally ran my last two +/− sheets for development.

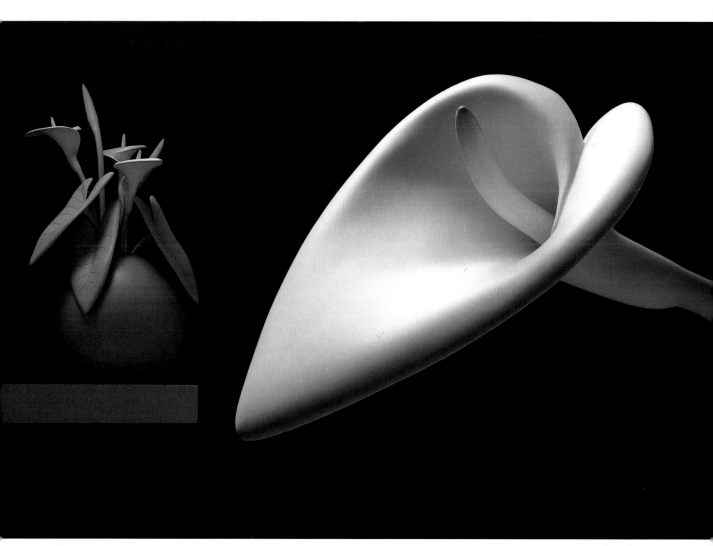

The final print is an excellent example of the simple use of a non-matte exposure. Using only two versions of the image, each was combined in a double exposure. The background was black velvet, which permitted the seamless juxtaposition of both elements in the final composite.

DOUBLE EXPOSURE WITH BACKLIT GRAPHICS
CAMERA FORMAT: 4 × 5
CLIENT: GERIATRIC OPHTHALMOLOGY

The eyesight of the elderly was the cover theme of an issue of *Geriatric Ophthalmology* I was assigned to illustrate. For this project, I decided to dramatize its visual impact by shooting a closeup of an elderly woman's eye, and adding an abstract spectrum of colors in a double exposure. The backlit graphic of the spectrum involved experimenting with different filters and created a strong design. Since I knew the model's flesh tone would be fairly light in value, I decided to keep the spectrum colors next to her face darker in tonal range. As a result, I would be able to overlap the backlit graphic and the eye exposure so that the lighter flesh tone would burn through in the final exposure.

STEP-BY-STEP

Eye exposure:
1. I sketched a comp of my idea of the final cover, positioning the face and eye in proportion to where I wanted the backlit graphic to overlap.

2. I positioned the model in front of a large drape of black velvet and used a single strobe in a medium softbox for illumination.

3. Using a 210mm lens on my 4 × 5 camera, I came in close on the model's right eye and shot down from an angle over her nose.

4. I shot test Polaroids to determine the correct exposure and checked my composition. I shot four frames: two frames at ½-stop overexposed, and two frames at ½-stop underexposed. I then made a tracing of the face outline, directly on my groundglass.

Creating the backlit spectrum graphic:
There are no hard and fast rules to follow when creating abstract light patterns; experimentation is the name of the game. Using sheets of black construction paper, I cut out various shapes from it and covered the patterns that were created with colored gels. I used different diffusion materials, such as Plexiglas and Flexiglas, to obtain a variety of soft and blurred effects. Then I

chose the specific shapes and colors to use for my final backlit spectrum.

5. I traced the shapes onto a clean sheet of Durolene in the position I wanted them. My comp was used as a guide. Then I inked in the tracing.

6. A negative litho was made of this art.

7. For the pattern, I taped small pieces of colored gels over the shapes on the litho and placed this art on the copystand.

8. For a stronger color effect, I did not use any diffusion materials; I opted to just throw the image out of focus with the copystand lens. For an added streak effect, I mounted a clear glass filter on my copy lens and carefully applied a thin coat of petroleum jelly to certain areas. I looked through the lens to see and control the effect.

9. I shot a text exposure of the effect. By process-ing one of the normal exposures of the eye I had determined that the best exposure of the eye was to push development by $+\frac{1}{3}$ f-stop, I adjusted my exposure of the backlit spectrum. Therefore, if normal development was $f/8+\frac{1}{3}$ I would shoot at $f/8$ and then push process for $+\frac{1}{3}$ exposure.

Final double exposure of eye and spectrum:

10. I positioned the spectrum in my viewfinder, using the traced outline of the eye image on my groundglass to guide placement.

11. I placed the glass filter over my lens.

12. Looking through my viewfinder, I threw the image out of focus.

13. I made my double exposure onto the same frame as the eye exposure.

DOUBLE EXPOSURE WITHOUT MATTES
CAMERA FORMAT: 4 × 5
CLIENT: CYCLE WORLD

CBS Publications decided that it wanted something different for its annual *Cycle World Buyers Guide*. I was given a comp, but the company's single requirement was that I show off Kawasaki's GPz 900 Ninja to its best advantage. This photograph was accomplished without the use of mattes, and it involved only two exposures. The entire background was a set I constructed from matte board. The bike was double-exposed onto the dark area on the lower right.

STEP-BY-STEP

Building the city set:
1. Using a 4-foot long piece of black matte board, I created a grid on it with string and pins, positioning the lines in a perspective receding to a single vanishing point.
2. I then "floated" the matte board several feet off the ground, using two C-stand arms to support it; I made sure the board was positioned exactly parallel to the floor.
3. After setting my camera above the board, I checked the alignment and perspective of the grid through the viewfinder, rearranging the string grid until I was satisfied.
4. To create an illusion of city lights in the distance, I punched holes in the matte board at various points along the grid. For the "window" shapes (in blue-green) along the right edge, I

used another piece of matte board and cut the shapes into it. The foreground structure was created with matte board also, and the square opening was cut and airbrushed silver. To each of these matte board constructions, light was supplied by softbox illumination: for the yellow city lights, I placed the softbox directly under the matte; the blue lights were created with the use of a large gel filter placed over the softbox; and a snooted strobe was directed at the silver-airbrushed square on the foreground structure. Some of the light from the snoot was allowed to spill onto the city grid, thereby giving a separation between foreground and background. Black velvet was hung in back of the city set to absorb light and produce a dark background.
5. To make the exposure of the city, I focused my camera lens on the large foreground shape and threw the city out of focus. This gave the city grid the appearance of being in the distance, which looked more realistic.
6. Three exposures were made of the city: the grid art was exposed through a yellow filter; the windows were exposed without filters; the foreground shape was illuminated by the snoot and exposed.

After I had shot several exposures of the set, I made a tracing of the individual elements directly on my viewfinder, as a guide for placing the bike in the composition.

The city set was created using a grid of lights and a large section of black board. The foreground area on the bottom right is where the motorcycle will be composited into the final image, on the following page.

Photographing the bike:

7. I first lined a 20-foot area with seamless black paper. The bike was rolled in and positioned on its side stand to be photographed.

8. A large softbox was used far behind the bike as the main light source. Flats were employed to direct the light away from the background. A strobe head with a small umbrella suspended from a boom was positioned above the bike's wind screen. A third light, a small softbox, was placed near the front tire as an accent light.

When I was satisfied with the position of my lighting setups, I prepared my exposure.

9. Placing the camera directly on the floor, I achieved a dynamic angle of perspective by shooting straight up. Using the tracing on my viewfinder as a guide, I framed the bike in the lower right corner. I masked off the rest of the elements by placing black construction paper over those portions of the lens. I then made my double exposure of the bike and the city.

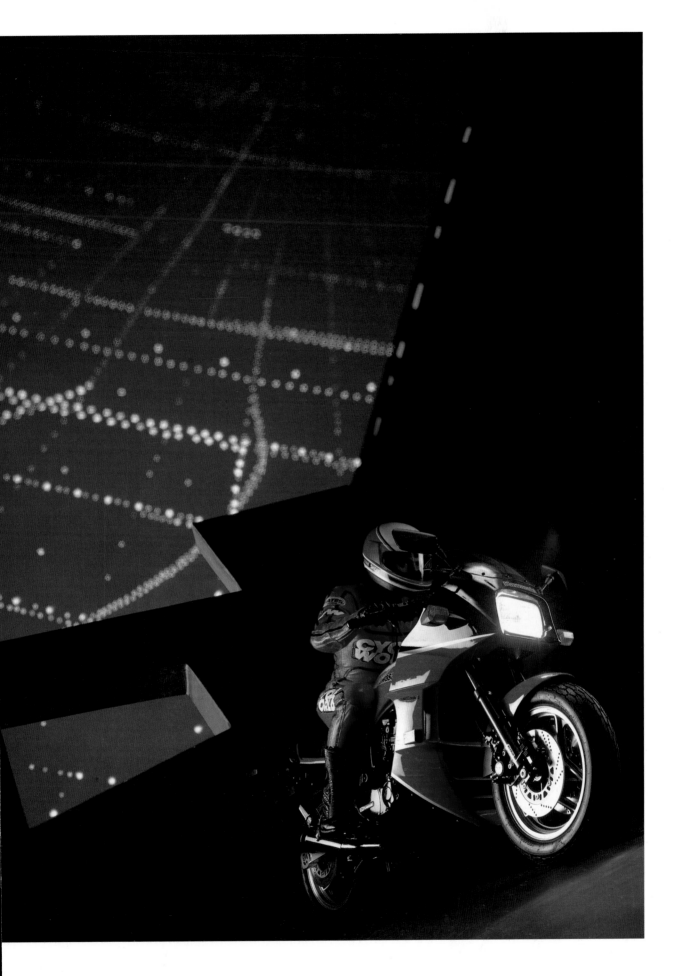

MULTIPLE EXPOSURE WITH BACKLIT GRAPHICS
CAMERA FORMAT: 35mm
CLIENT: FREED-CROWN-LEE PUBLISHING CO.

This editorial illustration was created for an article on financial planning. I came up with the idea to superimpose a graph into a crystal ball to represent looking into the future. This multiple exposure consisted of the ball and separate exposures for each part of the graph. These elements were then backlit and composited in the final image seen here.

STEP-BY-STEP

Crystal ball set and exposure:
1. I arranged the crystal ball on a table and hung black velvet behind it for a strong, solid black. I illuminated the ball from above and behind, using white reflector cards to kick in fill-light. My main concern was to light the ball in such a way that I could keep the center of it dark—it would be on that center area that I would expose the graph. After some test Polaroids, I made my exposure of the crystal ball.
2. I developed the film, and had an 11 × 14 stat made of the crystal ball image.
3. Using the stat as a guide, I sketched a curved graph within the ball. On another sheet of Durolene, I sketched a jagged line, using the graph sketch as a guide and overlay.
4. I placed the sketches on my light table and traced each of them in ink on Durolene. Using opaquing fluid, I whited out the areas on the graph where the jagged line would intersect the graph. This would prevent the graph from burning through the jagged line when the colors of each were composited later.
5. I had two negative lithos made, one of each ink drawing, sized 8 × 10. I used these negative lithos at my copystand workstation to create the red and yellow backlit art within the crystal ball.

Creating the backlit graph:
6. I positioned and mounted each litho on a separate pre-punched acetate cel.
7. I smeared a bit of petroleum jelly on a clear glass filter over my copy lens. This gave the graph a dreamlike effect and melded well with the idea of looking in a crystal ball at the future.
8. With the graph litho on the workstation, I placed a yellow filter over my copy lens and made several test exposures. I then removed this graph litho and replaced it with the jagged line.
9. With a red filter, I then made several test exposures of the jagged line litho.
10. When I had chosen my best exposures, I was ready to composite the final image.

Final multiple exposure:
11. In the studio, I photographed the crystal ball.
12. Keeping the 35mm camera in the same position, I carefully sketched the ball's position on my viewfinder. By doing this, I could exactly position the graph within the center of the ball.
13. At my workstation, I placed the yellow graph on the shooting surface. Using the sketch on the viewfinder, I sized and positioned the graph within the ball.
14. Now I was ready to expose the yellow graph. I exposed the graph using a yellow filter over the lens, and a glass filter that I had smeared with petroleum jelly, for a soft-focus effect.
15. I removed the yellow graph from the copystand and replaced it with the jagged line.
16. I exposed the jagged line through a red filter.

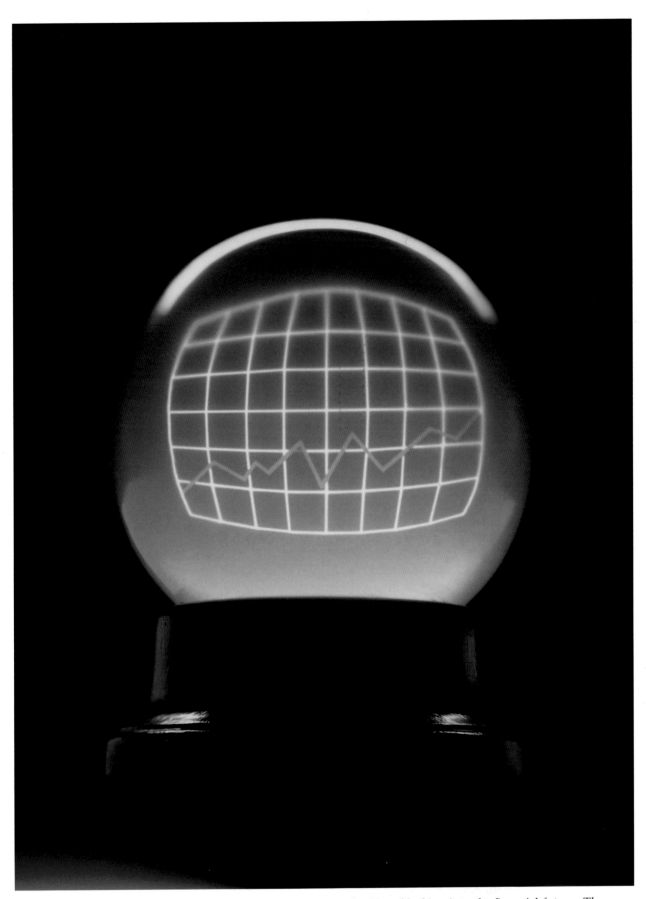

The resulting image is a graphic concept that clearly connotes the idea of looking into the financial future. The backlit graphics of the grid chart were composited as a multiple exposure with the photograph of the crystal ball.

MULTIPLE EXPOSURE WITH BACKLIT GRAPHICS
CAMERA FORMAT: 4 × 5
CLIENT: PAYNE SYSTEMS

For this advertisement, the client's art director wanted to illustrate both a Payne heat pump and a large circuit board streaking out of it. My first challenge was how to shoot the assignment without the use of dupes, which would lose substantial sharpness. The streak effect also had to be very exact.

Because the art director wanted to see a finished transparency on the day of the shoot, my plan was to use three 4 × 5 cameras: two set up in my studio area and one at my workstation. Each camera would be shooting a separate element and then all shots would be combined for the final image.

STEP-BY-STEP
Before the arrival of the air conditioning unit and the circuit board, I spray-painted the cove area where I planned to photograph them. I used flat black paint for the top of the cove and medium gray for the bottom.

1. I arranged the air conditioning unit according to the client's comp, placing the unit on the far left of the cove. Then I traced the position of the unit onto my camera groundglass.
2. In a corner of my studio, I set up the circuit board on a small table draped in black velvet. Using the second 4 × 5 camera, I placed the tracing of the air conditioning unit onto this second camera's groundglass as a guide to position and photograph the circuit board.
3. I made test Polaroids of both the air conditioning unit and the circuit board, and used the Po-laroid test prints to make a comp of their respective positions.
4. With the above comp, I traced in where I wanted my streaks flowing from the air conditioning unit to the circuit board. I then had an 8 × 10 stat made of this streak tracing.
5. I placed a sheet of Durolene on top of the 8 × 10 stat and drew several lines in ink to simulate the streak effects.
6. I then shot the inked Durolene onto litho film at 100 percent, and then contacted this positive litho. This produced a litho negative: a solid black background with clear streak areas. I then cut and placed green and yellow Pantone color material in the clear sections to produce the streak effect color.
7. Next, I placed the third 4 × 5 camera on my copystand. Using the comp made from the test Polaroids, I sized and positioned the streak artwork. I placed diffusion Flexiglas over it and made text exposures for the final effect.

The final composite:
8. When the art director arrived at my studio with the model, I positioned the model at the air conditioning unit and made an exposure with the *first* camera. I removed the film from that camera and placed it in the *second* camera for the shot of the circuit board. I made my exposure. I then removed the film from that camera and placed it in the *third* camera, set up at the workstation. Using the same film, I made the final exposure. The art director had the multiple-exposure transparency that same day.

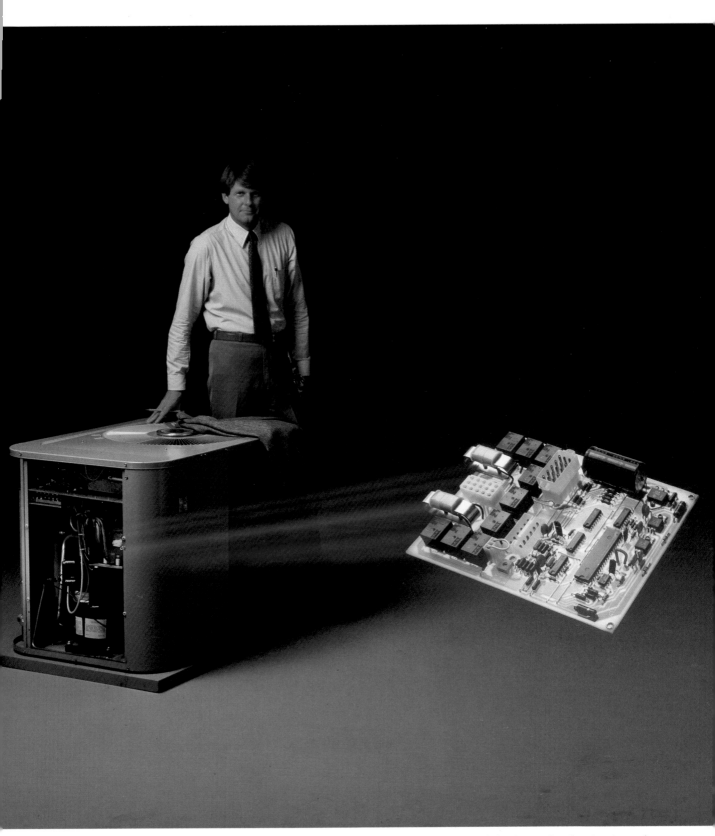

This image was composed of three elements: the photograph of the model and air-conditioning unit, the circuit board, and the backlit graphics of the streaks. All three were combined into one multiple exposure with the use of three separate camera sets for each element.

MULTIPLE EXPOSURE WITH BACKLIT GRAPHICS
CAMERA FORMAT: 4 × 5
CLIENT: PHONEMATE

The client's advertising agency wanted a unique look for a new campaign launched to promote the client's telephone answering equipment. The project incorporated a built set, backlit graphics for the horizon glows in the background, and the telephone products.

STEP-BY-STEP

Creating the set:

1. I built an 18 × 20-inch tray out of Formica. It was approximately one inch deep. Into this I placed enough ball bearings to fill the whole tray. By shifting the surface as the balls were placed in, I was able to line them up in straight rows. When I was satisfied with this set, I spray-painted the surface of the balls a flat black.

2. Using a 90mm wide-angle lens on my 4 × 5 camera, I positioned it less than an inch away from the front row of balls. I illuminated the set with a medium-sized light bank, positioned overhead. I wanted to achieve a vanishing perspective of strong highlights fading off into a darker horizon. After shooting some test Polaroids, I made my exposure. I did not use a colored filter over the lens because I wanted to keep the highlights on the ball bearings a neutral tone as a foreground element.

3. The horizon line was created as a backlit graphic, using the horizon explosion method (see page 37). I drew the art on Durolene, and then shot this onto litho film. Using the test Polaroid of the set as a guide on my camera groundglass, I carefully positioned and sized the horizon explosion where I wanted it to appear in the final image. At my copystand I then photographed the horizon litho through Plexiglas, without a filter. I now had a transparency of the horizon explosion and the ball bearings.

4. At my light table, I mounted the transparency of the ball bearings onto an acetate cel. On top of this, I positioned another clear acetate. Using the transparency of the ball bearings as a guide, I mounted the horizon explosion transparency.

5. I removed the acetate of the ball bearings. Keeping the horizon explosion on my light table, I positioned a clear acetate on top of it. I then taped a piece of black construction paper over it so that everything *below* the horizon line was covered by the paper.

6. Photographing the entire line of Phonemate answer phones was a bit of a challenge due to the fact that half the products were black and the other half were light beige. White cards had to be placed strategically behind darker products to separate them from their backgrounds. Black velvet was placed around the lighter colored products. Small bits of tape and card were placed in strategic locations to aid in creating separation. A large, translucent silk flat was hung over the set. With the aid of booms, four strobe heads were positioned over this silk flat for illumination.

Making the final composite:

7. At my workstation, I placed the transparency of the ball bearings on the copystand. I made the first of three exposures, using a red filter over the lens.

8. The second transparency I shot was the horizon explosion. I placed a yellow filter over my lens and made my second exposure. The bright yellow color was bled into the ball bearings to marry the horizon to the foreground.

9. After removing the horizon art, I placed the background art on the copystand. After I made this exposure, all elements were complete.

The constructed grid of the ball bearings were combined with a horizon explosion backlit graphic and photographed with a yellow and red filter. The actual phone machines were photographed separately and then composited into the final image (on the following pages).

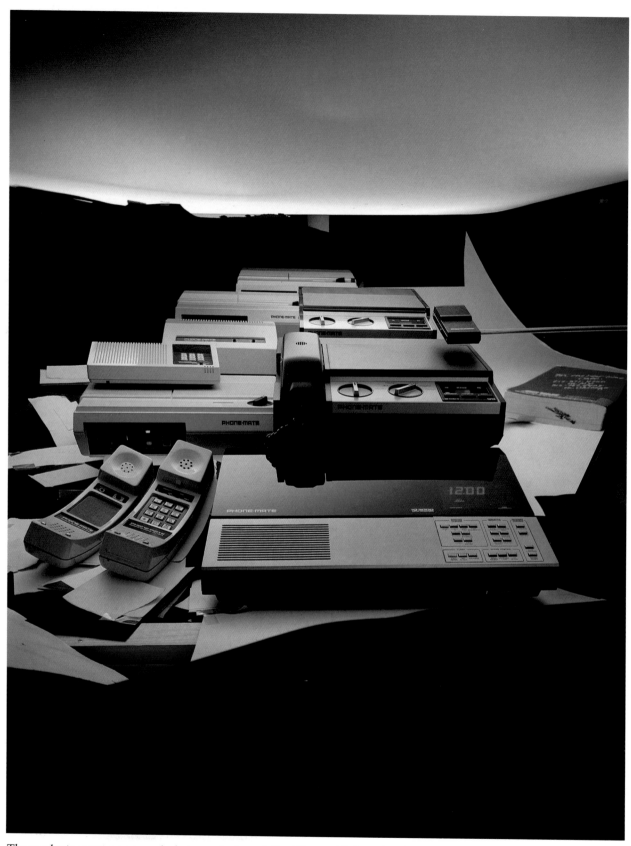

The products were set up and photographed carefully. Pieces of light-colored paper were strategically positioned around each component to help define edges during the matte-making stage.

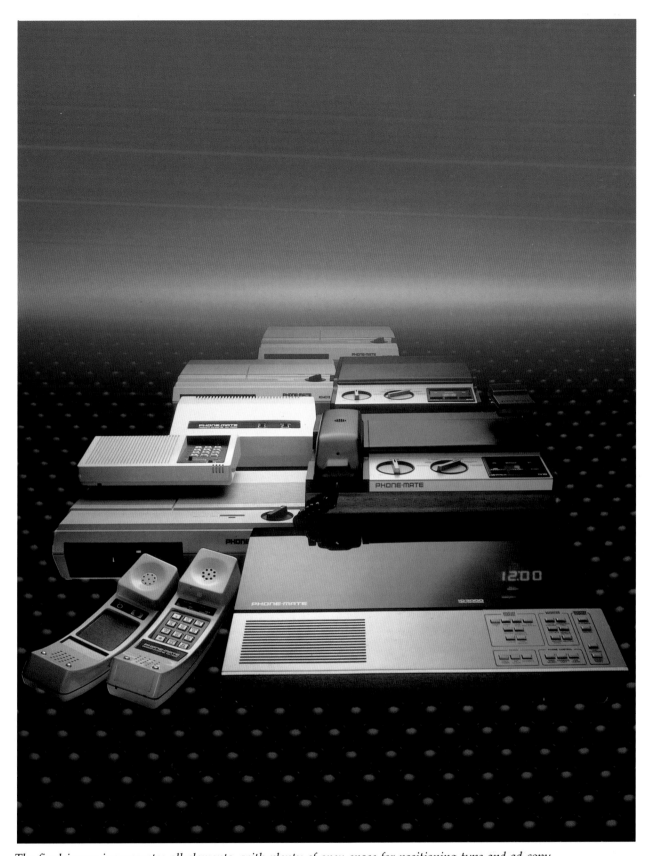

The final image incorporates all elements, with plenty of open space for positioning type and ad copy.

MULTIPLE EXPOSURE WITH RUBYLITH MATTES
CAMERA FORMAT: 35mm
CLIENT: VESPA

As a change of pace from the usual display images of motorcycles, I decided to do something more interesting with this Vespa scooter. The project involved stripping the scooter itself out of its original photograph, which was an image of the bike sitting in front of some old gas pumps, with a model in the foreground.

The second component of the shot, the blue grid surface, was a building in West Los Angeles, nicknamed the "Blue Whale": the Pacific Design Center. I thought it would make a wonderful background because of its rich blue-green color. But after shooting a few exposures, I realized the color seemed darker than I wanted. However, upon going back and photographing it in the hours of the early morning, the grid pattern on the building appeared golden in the rays of the early sunlight. To get an exposure combining both the rich blue color and the gold grid in the same image, I used a double exposure.

First, I photographed the blue glass surface of the building in late afternoon light; I rewound my film . . . and then I waited—*all night*. At sunrise, when the earliest golden rays skimmed the glass surface and illuminated the grids, I made my second exposure on the same frame of film. This would be the background onto which I would composite the image of the red scooter. The other elements in the image were pieces of art created as backlit graphics to be composited into the final image also.

STEP-BY-STEP

To strip out the scooter from its background:
1. The original image was enlarged and printed on 8 × 10 continuous-tone (velox) stat paper.
2. At my light table, I placed a sheet of rubylith over the entire stat; I then carefully cut around the shape of the scooter, pulling the rubylith material away from the surrounding area. This left the exact shape of the scooter, which was masked with rubylith.
3. I made an 8 × 10 negative (window) litho of the rubylithed matte (by contacting the ruby matte to a sheet of Kodalith). I then made a reduced size window, which I planned on using in the final composite.
4. I contacted this window litho of the scooter

with another sheet of unexposed litho material, producing a positive litho of the artwork. I then placed this bike matte in my 8 × 10 Condit frame to prepare my composite.

Creating the background mountains:
The background elements consisted of the mountains and sky, the clouds, and the building. To create the mountain range, I drew and inked them on a clean sheet of acetate. Below the mountain range, I inked in a solid black area; above the peaks, I left the acetate cel clear.

1. I placed the mountain range litho on my workstation. While looking through the viewfinder of my copystand camera, I moved the camera up and down the elevator until I positioned it at the correct size, making sure the peaks of the mountains were at the very top of the horizontal frame.
2. I adjusted the lens so that it was slightly out of focus. This gave the appearance of the mountains being in the distance. With a red filter on my camera, I made an exposure.
3. I marked the outline of the mountains on my camera groundglass.
4. I removed the mountain art and replaced it with the cloud art. Using the groundglass tracing as a guide, I positioned the litho. I had airbrushed the cloud shapes on Durolene, and then shot them onto litho film.
5. I double-exposed the clouds on the same piece of film I used to shoot the mountains. This, too, was put out of focus for the same effect. No filters were used because I wanted the clouds to appear white and burn through the black, red, and blue. Now I had an exposure of the mountain and clouds, with a solid black area below in the foreground.
6. Using the mountain range outline on my groundglass as a guide, I positioned the transparency of the blue building just below the mountains. Earlier I had masked off the sky area at the top of the building so that only the glass and grid appeared on the transparency. With the transparency of the building in its correct position, I then locked the camera down and made an exposure.

The original image of the bike. All of the background elements were stripped out.

The grid pattern of the building was a result of a double exposure. When the building was lit up by the rays of the early morning sunlight, the grids turned a golden hue. Using the same frame of film, I exposed the image of the blue glass surface. This double exposure was then incorporated as a composite with the original transparency of the bike and the backlit graphics of the mountains in the final image.

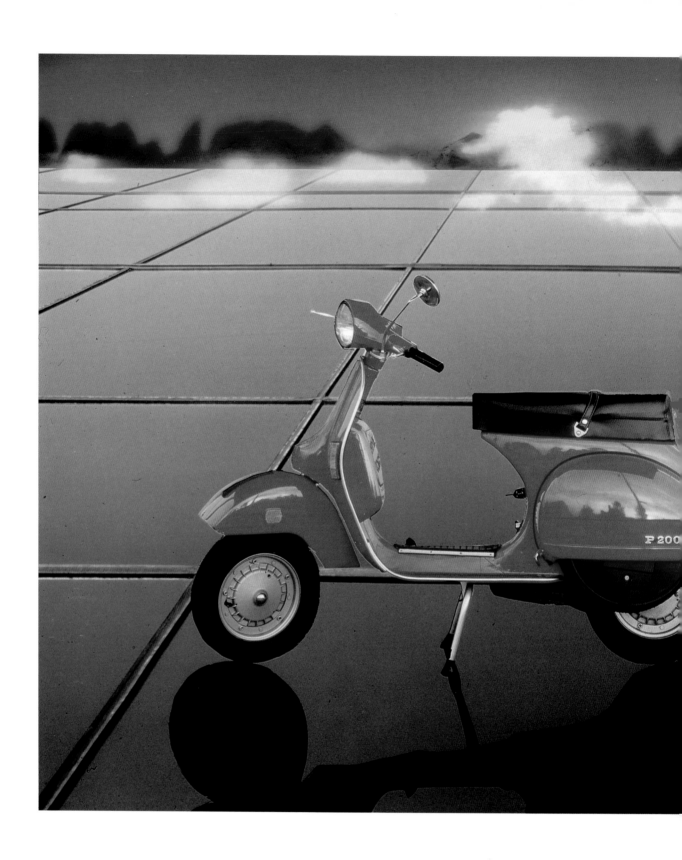

Compositing the elements:

7. Using my enlarger, I projected the image of the building within the area of my 8 × 10 registration frame, and placed the matte of the scooter exactly where I wanted it on the gridwork of the building. I blocked off this portion so I could replace the frame in the same position each time.

Shooting the final composite:

8. In complete darkness, I placed an unexposed sheet of 8 × 10 dupe film on top of the matte. I closed my registration frame and using the blocks, placed the frame in the exact position as before.

9. I made the background exposure (clouds, mountains, and building). I returned the exposed film to its light-safe box.

10. Next, I placed the bike window litho in the registration frame, a sheet of white paper on top of the litho, and a scrap piece of transparency film on top of this sheet of paper.

11. I closed the registration frame and positioned it under my enlarger.

12. The scooter image was then projected down onto the window litho and sized to fit within the window, with a hairline of bleed all around. The scrap film and white paper were removed.

13. In complete darkness, the film was placed on top of the window litho, and the frame was closed. I checked the registration for accuracy.

14. I made my final exposure, with all the elements combined on one piece of film.

SIX-PART MULTIPLE EXPOSURE WITH BACKLIT GRAPHICS
CAMERA FORMAT: 4 × 5
CLIENT: XEROX CORPORATION

The Xerox Corporation wanted me to come up with a design for a promotional brochure illustrating the theme of the merging of minds and computers. The principal elements for this project consisted of a computer keyboard, a mannequin head, two floppy disks, and a backlit graphic glow. No mattes were involved, so I was able to photograph each element to the size of the finished piece. After mounting each transparency on individual acetates, I made the final multiple exposure on the copystand.

STEP-BY-STEP

1. The computer keyboard was lit and photographed to the correct perspective I needed, using a black velvet background. I made Polaroid tests of the set, checking each for the clarity of the figures on the keyboard, and the eveness of lighting. When I was satisfied with the test shots, I made a final exposure, which was used in the final photo composite.

2. The mannequin head was also photographed to size, illuminated with an undiffused single strobe that was positioned to create a rim of lighting outlining the head. With the use of a snoot over the strobe head, I was able to prevent the light from spilling onto the background. I used a red filter to create the color.

3. I shot the floppy disks separately so that I would be able to reposition them in the composition of the final image. I used fine, monofilament wire to suspend them from the set and background. They were illuminated with a single softbox, positioned at the side. I used a wide-angle lens for a more forced perspective. A cyan filter was used for color.

4. I made a stat of each of these four transparencies, shot at 100 percent. I then cut out the individual elements from the stats and, using my comp as a guide, created a position stat combining all the elements for the final image. This montage was mounted onto an acetate cel. I used this stat montage as a guide to mount each of four transparencies on individual acetate cels.

5. To photograph the computer monitor type, I first had to make some exposure tests. It's always a good idea to do a great deal of bracketing because different monitor screens will vary in their lighting output and color of the type on the screen. After I had taken a few Polaroids, I chose my best exposure and photographed the screen.

6. From the screen monitor transparency, I cut out the type area carefully.

7. Using the montaged position stat as a guide, I positioned the monitor type on an acetate overlay and masked out everything surrounding the type, using black construction paper.

8. I positioned an acetate cel of the foreground disk transparency on registration pins at my light table and placed a clear acetate cel on top.

9. Using a Rapidograph ink pen and a triangle, I drew a line along one edge of the foreground disk and part of the way up one side. I made a negative litho of this artwork; I would use this for the pink glow.

10. Using the position stat on the light table, I positioned the litho of the pink glow on an acetate overlay.

Final composite:

11. I placed the keyboard, head, foreground disk, and background disk one at a time on the copystand and exposed each.

12. I placed the monitor type litho on the copystand and made an exposure using a green filter.

13. I placed the glow litho on the copystand and diffused it by overlaying a sheet of Plexiglas on top. I made my exposure with a pink filter.

14. After all elements were photographed, I had my single image.

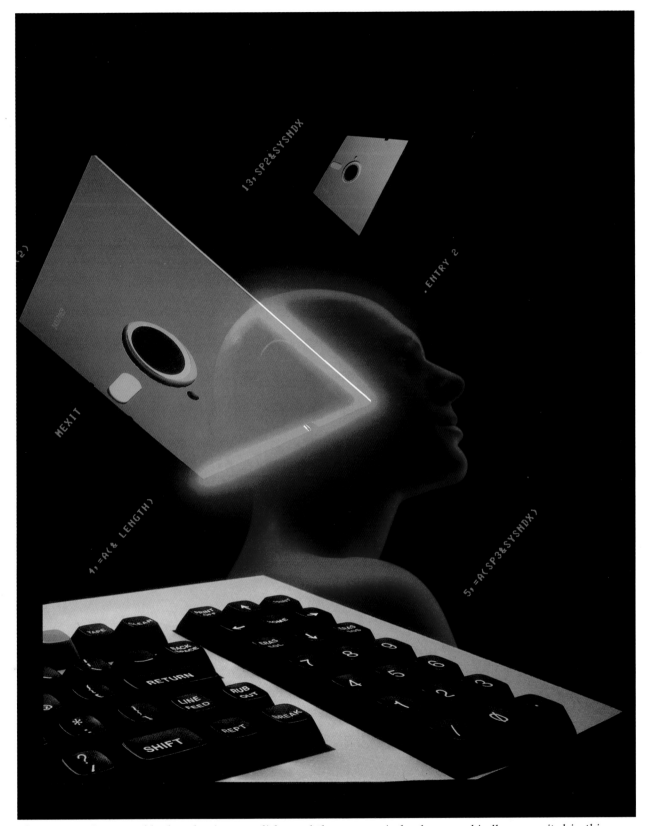

The separate elements of keyboard, computer disks, and the mannequin head are graphically composited in this striking image for Xerox Corporation.

MULTIPLE EXPOSURE PHOTO COMPOSITE WITH BACKLIT GRAPHICS
CAMERA FORMAT: 8 × 10
CLIENT: BECKMAN INSTRUMENTS

This image is a five-part photo composite. I worked from a fairly exact comp, supplied by the client. My job was to take this fantasy idea and make it real on film.

The components consisted of: 1) the computer, 2) the screen readout, 3) the colored ribbon, 4) the foreground hand, and 5) the background hand.

STEP-BY-STEP

Creating the individual elements:

1. I set up the computer on a piece of black velvet, to give the illusion of it floating in space. Using a large umbrella, I bounced light into it. The main light was positioned above and slightly in back of the screen, to make sure the screen would go very dark. I made two exposures: one of the computer, and then another of the readout, each on a separate sheet of film. I burned in the readout later on the final composite of the image.

2. I next set up the hand. To get a slick, highly reflective black, I first stretched a tight-fitting surgical glove over my model's hand, taping it securely around his wrist. I rested his wrist on a sandbag covered in black velvet, and I held his hand in the exact position I wanted with the aid of a C-stand arm. I placed a wedge painted black in his palm to keep the position of his fingers exact. When everything was right, I spray-painted enamel onto the gloved hand.

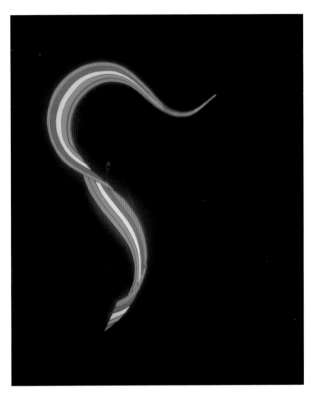

The lighting had to match the light source of the computer shot, so I used a small softbox above and in front of the hand. I placed a white card a few inches from the model's thumb for fill light. I then made my exposure.

3. I made one stat of the computer transparency, as well as one stat of the screen readout, sized to fit my 8 × 10 format.

4. I also had a stat made of the hand to fit my 8 × 10 format camera, and, using the same transparency, I flopped the image of the hand, reduced it to the size I wanted for the background hand, and made a stat of this.

5. From the stats of the computer, the screen readout, and the large and small hand, I cut each out, placed and taped all of them on an acetate cel in the exact position I wanted them to be (using the comp as a guide).

6. I put a clean sheet of Durolene over the stats and backlit them on my light table. Now I penciled in the ribbon shape, flowing from one hand to the other, over the computer. I inked in the ribbon shape to a solid black.

7. I made a positive and a negative litho of this artwork, at 100 percent of its original size.

8. Using colored Pantone paper, I cut strips and applied them to the negative litho. To give the illusion of shadow at the twists of the ribbon, I airbrushed a light black shadow on a separate piece of acetate, which was placed over the negative litho. This separate acetate would be used later in the final exposure.

9. To soften the Pantone colors, I placed sheets of Flexiglas over the ribbon litho.

10. By placing the position stat under my enlarger, I sized each transparency of the hands, computer, and screen readout by projection. Then I made a dupe of each.

11. I contacted the hand dupes onto litho film, which gave me a negative litho of each hand.

12. To create a solid matte of each of the hands, I painted black opaque onto the clear areas of the hand litho where needed.

13. I then made a contact positive litho from each of the above negative hand lithos, in order to produce a window to be sandwiched to each of the hand dupes.

Positioning the components on separate acetates for compositing:

14. I first placed the acetate with the stats on it on the registration pins at my light table.

15. I placed a clean acetate cel on top of this.

16. I taped the transparency of the computer to the acetate, using the stats as a position guide.

17. Removing the computer transparency cel, I placed another clean cel on the registration pins. Then I placed the litho matte of the *foreground* hand on it and taped it in place.

18. I removed the foreground hand cel, and placed a third acetate on the pin bar. Onto this, I taped down the matte of the *background* hand.

19. I removed the background hand cel, and placed a new acetate down on the pins. Over this, I then taped down the matte of the ribbon.

20. I removed the ribbon cel and placed a new acetate sheet on the pins. On this, I taped down the transparency of the screen readout.

At this point I had the following elements each taped to an acetate cel: the computer transparency, foreground hand matte, background hand matte, ribbon matte, and computer screen readout transparency.

Because the ribbon matte and both mattes of the hands had the pin-register holes in them, it was very easy to position the ribbon artwork and the transparencies of the hands: I first placed each of the acetate-mounted matte on the registration pins. Then I cut a small hole through the acetate cel around each pinhole in the matte. Next, I placed a Condit pin under the acetate and through the hole in the matte. I did this for each hole. Then I placed a clear cel on the registration pins, cutting around each pin so that the acetate would lie flat. I then taped down the art/transparency of the ribbon and hand transparencies. I made test exposures of each of the transparencies and the ribbon artwork.

Now I was ready for the *final composite*:

1. I placed the foreground and background hand mattes on the copystand.

2. I placed the Pantone-colored ribbon mattes over the hand mattes.

3. I placed the computer transparency over the ribbon mattes.

4. Focusing on the computer, I made an exposure.

5. I removed all of the artwork from the copystand workstation.

6. I placed the foreground hand transparency down and made an exposure.

7. I repeated Steps 5 and 6 for the background hand transparency.

8. I repeated Steps 5 and 6 for the computer screen readout.

9. I placed the ribbon artwork down on the workstation and made the final exposure.

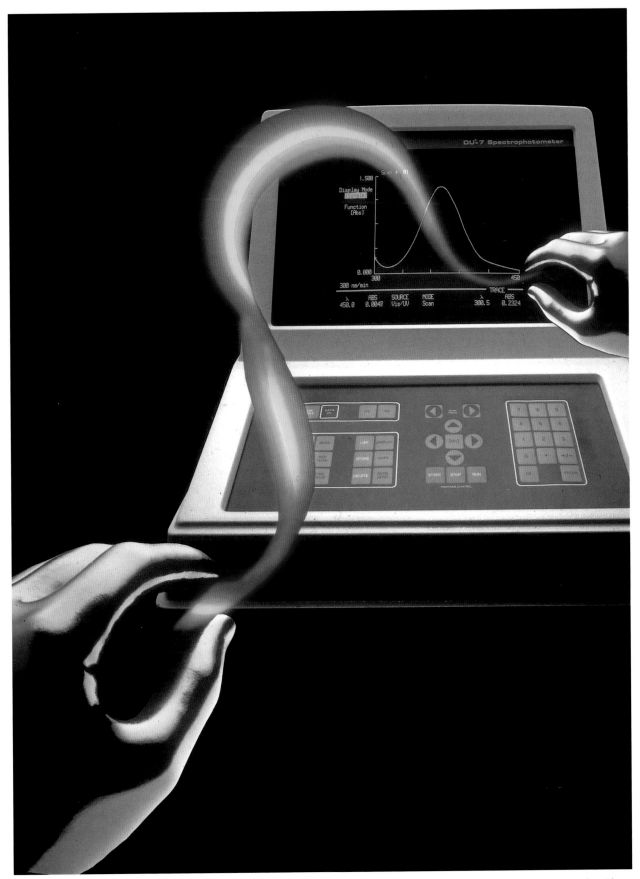

In the final image the backlit graphic of the ribbon effect is smoothly integrated with the computer and hands. The hands were created with a single exposure, and then flopped and reduced in size to produce the second one.

MULTIPLE EXPOSURE COMPOSITE WITH BACKLIT GRAPHICS
CAMERA FORMAT: 8 × 10
CLIENT: BECKMAN INSTRUMENTS

This is another in a series of advertisements I produced for Beckman Instruments. The art director decided, as with the ribbon and computer image (see page 85), to show a spectrum of color in an unusual graphic concept: here, a lightning bolt from the sky.

The product to be illustrated was a fragile, credit card-sized gel of clear plastic. This image was a seven-exposure composite consisting of: 1) background sky and mountains, 2) foreground quartz mass, 3) lightning, 4) hand and card, 5) light blue streaks coming through card, 6) blue glow around card, and 7) spark at the tip of the lightning effect.

The printing on top of the card was not a good, contrasty black; to improve it, I made a contact positive litho and sandwiched it to the back of the actual card with mounting spray. This made the lettering much clearer for use in the rest of the shooting sequences. The quartz foreground was actually three large pieces, which I joined to fill an area about four feet square. I purchased the hand at a mannequin shop. Because it was fiberglas, I had to sand it repeatedly and then apply a primer coat of paint. To achieve a truer chrome look, I had the hand vacuum-metalized. The background mountain range and sky were created on my copystand using inked acetate cels photographed through a soft-focus filter. The lightning, white glint, and blue glow were all backlit art I created for the image.

STEP-BY-STEP

The individual elements:
1. Before photographing the card gel, I glued it to the hand and secured the hand to the arm of a C-stand clamp.
2. I built a small, "C"-shaped cove out of mountboard and lined it with Mylar. The Mylar would produce an added effect of chrome into the silver hand.
3. I cut a slit in the Mylar, the width of my lens (I was shooting 8 × 10) and parallel to the floor. This would prevent my lens from reflecting back onto the hand and showing in the image. It also produced some black down the thumb and finger, which helped reinforce the chromelike appearance. I made my exposure.

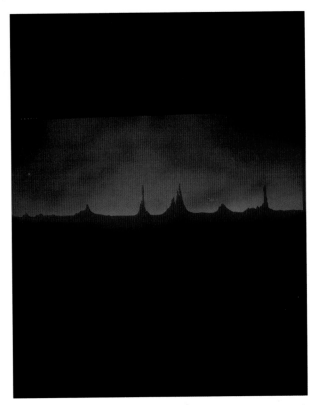

4. Because the card gel was translucent, I placed a large piece of the quartz behind it, which would marry it to the foreground quartz in the final image; to make the type on the card stand out more clearly, I threw the quartz out of focus.

5. The foreground quartz was photographed against a large piece of black velvet. A large softbox, placed directly overhead, illuminated the quartz. I placed a small, black card in front of my lens, so that the quartz would seem to fade off to black. I made my exposure.

6. With the card gel/hand transparency and foreground quartz transparency shot, I had a stat made of each image to fit my 8 × 10 format. I would use these stats as a guide in placing and sizing elements of the image in the final shot.

7. I first cut out the shape of the card gel and hand, and positioned it onto an acetate cel. I then taped it down.

8. I then cut out the shape of the foreground quartz from its stat and positioned and taped it down on the same piece of acetate. This cel would be the size guide for the other elements.

9. For the background sky and mountains, I inked in the mountains on an acetate cel first placed over the position stats. I then airbrushed a separate cel to give the illusion of a stormy sky. Next, I sandwiched the two cels.

10. Using a violet filter in front of my lens, I made an exposure for the colored sky and black mountains; to soften the image, I later added a soft-focus filter. I made some test exposures.

11. To create the lightning effect, I drew my image onto an 8 × 10 sheet of Durolene, which was placed over the position stats as a guide.

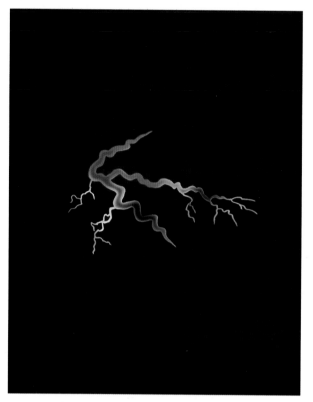

12. I made a positive and a negative litho of the lightning artwork I had inked, at 100 percent.

13. I taped the negative litho onto an acetate cel, using the position stats as a guide.

14. Color was added to the lightning by cutting out pieces of Pantone paper and adhering them to a separate acetate cel. This was placed over the negative litho of the lightning.

15. For the final lightning effect the artwork was placed on the copystand in order: I first lay down my positive litho on the copystand. This would create the darkened center of the bolt.

16. Next, I placed the Pantone colored acetate on the copystand, over the positive.

17. I then placed a sheet of Flexiglas on top of these, to soften and blend the colors.

18. Finally, I placed the negative litho on top of everything.

19. After making test exposures, I chose an exposure for use.

20. To create the blue glow lines in the image, I made lithos and backlit them shooting through a blue filter:

Using clear acetate cels over my position stat, I inked in each of the glows; one piece of artwork was for the thin blue line around the edge of the card gel, and the other was for the lines streaming out of the card gel itself. From each of these, I made a negative litho at 100 percent.

21. Using my position stat as a guide, these two lithos were then positioned and taped on acetate cels separately. I made test exposures at my workstation copystand, shooting through Flexiglas with a blue filter.

22. The spark on the tip of the lightning was created by greatly overexposing a tiny pinhole (made in a sheet of unexposed litho film) through Flexiglas, without a filter.

Compositing the final image:

23. The card gel/hand transparency was placed on the copystand, focused, and exposed.

24. I removed the first transparency and then placed the matte for the lightning and the card gel/hand on the copystand.

25. On top of these mattes, I placed the art (mounted on separate acetate cels) for the background sky and mountains, and made an exposure of it.

26. I took off the background sky and mountain art leaving the mattes, and placed down the 8 × 10 transparency of the foreground quartz; I made my exposure.

27. The quartz transparency and both mattes were next replaced with the lightning art and then exposed.

28. The lightning artwork was removed. Each of the two blue glow lines was placed on the copystand and exposed.

29. Everything was removed, and I positioned the spark tip art on the copystand alone. I made an exposure.

30. With all multiple exposures made, I processed the final film.

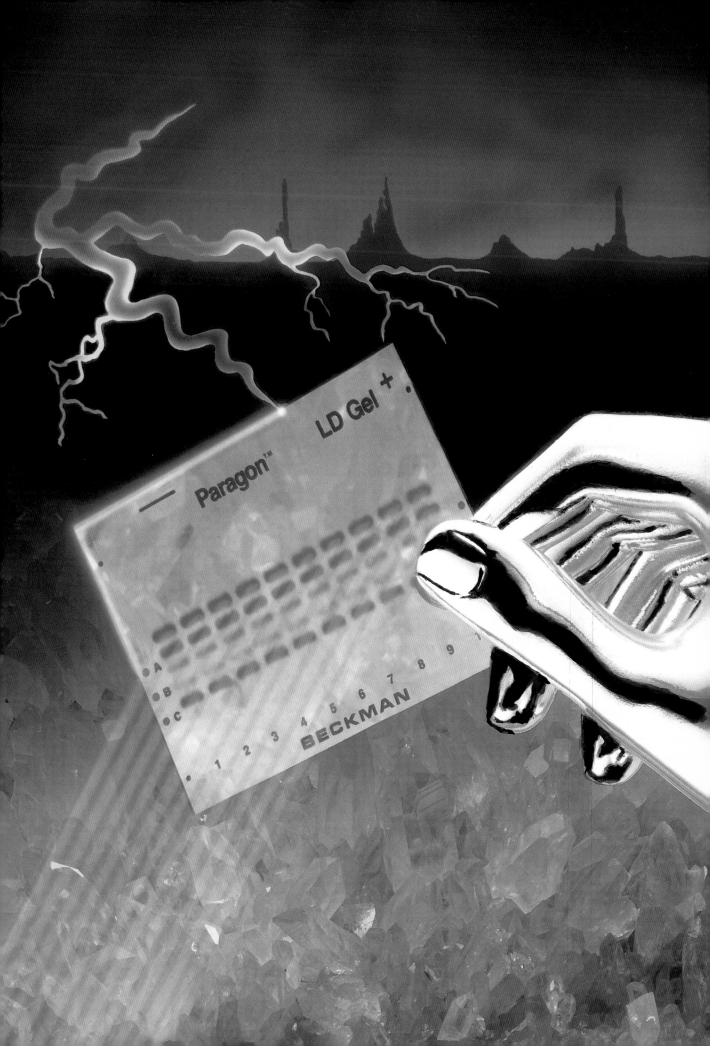

THREE-PART PHOTO COMPOSITE
CAMERA FORMAT: 4 × 5
CLIENT: SUZUKI

To illustrate what was being advertised as the "hottest super-bike" introduced by Suzuki, I wanted to convey the power and speed of the machine by showing it racing down a stretch of road, and seemingly coming right at the viewer. The photo composite included art for the streaks and yellow turn signal, burned in during the final stages of compositing.

STEP-BY-STEP

1. I began by building a miniature road set in my studio. I created it with an exaggerated angle of perspective, which would be further enhanced when photographed with a wide-angle lens. I then made the road from a thin piece of foam-core that was cut so that the back part of it tapered to a point. I painted the sides a flat black. To give the illusion that the front of the road had broken off, I glued tiny pebbles, painted flat black as well, to the front. Then I adhered a piece of gray Pantone paper to the top surface and used yellow strips of Pantone to indicate the dividing lines. With this model supported by a C-stand, I photographed it against a backdrop of white seamless. The photograph of the motorcycle was supplied by the client. Because of some surrounding details in the image, I had to strip out a number of them using a rubylith mask.

2. I created the background by compositing a strip of turquoise with a field of lavender. To do this, I first taped a strip of black litho on a clear acetate cel, and then made a contact litho negative. Contacting this litho again produced a litho positive. I used this positive litho at my workstation, shooting it with a piece of Plexiglas for diffusion. A lavender filter added to my lens created the color.

3. I double-exposed the litho *negative* through another sheet of Plexiglas, with a turquoise filter on my lens this time. I then shot the final background transparency on 8 × 10 film.

4. The yellow lines on the turn signal were drawn on Durolene and shot onto litho film. This art was exposed in the final film through a yellow filter *and* a sheet of Plexiglas. The white streak on the front brake was created by scratching a piece of litho with a needle, and I shot the art with a covering of diffusion material, overexposing for a soft effect.

5. In preparation for the final shot, I had to create mattes to drop in the road and bike against the background. Because these two elements were not set against a matte black background, I also needed to make litho negatives to act as windows for each transparency. Now my art and transparencies would consist of the following: the image of the motorcycle, road, and background; mattes of the motorcycle and the road, and a single matte of them both; and lithos of the turn signal lines and white streak.

The final composite:

6. I placed a clear acetate cel, mounted with a clear litho, on my copystand. I positioned the transparency of the bike on top of them and made an exposure. I then removed these cels.

7. Next, I positioned the background transparency over the bike and road matte, which I had combined on one litho. I made another exposure at the copystand.

8. A third exposure was made of the bike transparency, and then a fourth, of the road.

9. The glow around the bike was achieved in three steps: I first removed the Plexiglas from the copystand and placed a litho negative of the bike on the registration pins. I replaced the Plexiglas in position over it. Then I put the bike matte on the copystand; this produced a white glow wrapping around the matte of the bike. To add color to the glow, I made an exposure through a pink filter, double-exposing this film against the background to get a test of the intensity of the glow. If you expose the glow against black, it will appear very hot; if you expose it against a lighter tonal value, it will be softer.

10. I next placed my litho of the turn signal dashed lines on my copystand. Over this I placed white translucent Plexiglas and exposed with a yellow filter.

11. I made the final copystand exposure for the white streak litho using several layers of Plexiglas placed over it for diffusion. The final image, on a single frame of film, was composed of all these elements.

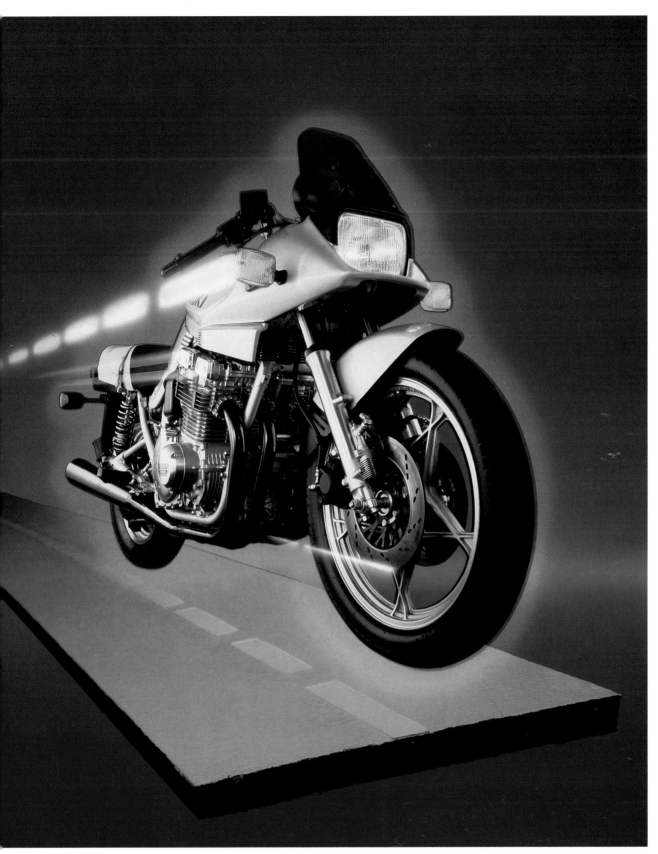

The powerful final image gives the impression of the bike racing forward out of the page and at the viewer. The effect of motion is created by the backlit graphics of the turn signals and the streaks on the tires. The road was a single set constructed in my studio and then photographed and composited into the image.

PHOTO COMPOSITE WITH COMPUTER GRAPHICS
CAMERA FORMAT: 4 × 5
CLIENT: NORTHSTAR

Northstar had planned to introduce a computer that would compete with IBM, and even though this proposed product was still under development, the company wanted to plan an advertising campaign around it. The art director sent me a comp, illustrating a single computer with a grid around it. But later, when I visited the company plant, I received a later comp featuring not one but 12 computers, stacked two high and two deep. Each computer had a different image on its screen. The stack of computers was enclosed within a computer-generated grid. This was the image I had to create. The monitor that served as my model was only a mockup, with no screen. My first task was to photograph this; then I would need to duplicate the image, size each within the grid, compose the grid, and finally composite all the pieces.

STEP-BY-STEP

Photographing the computer monitor:
1. The principal set consisted of the monitor and a cordless keyboard, positioned on top of a black velvet base, which isolated the components clearly. I also taped black velvet inside the monitor screen area. This would enable me to double-expose graphics onto the screen. The set was illuminated with a medium-sized light bank, from above. This set, the first exposure, would be duped 12 times for compositing.

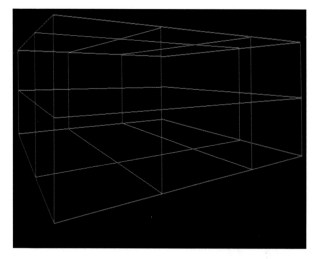

2. I replaced the set with a working monitor and made separate exposures of six different screen readouts. I photographed in the dark, to ensure clarity of the screen images.

3. With the aid of a Lucigraph, an opaque projector used to trace artwork, I drew a comp of the monitor and keyboard, stacked in the desired perspective and reduced to the final image size I wanted. With this comp as a guide, I had twelve 4 × 5 dupes made at a custom lab. From these dupes, I had stats made at 100 percent enlargement. Using the Lucigraph tracing as a guide, I mounted the stats in position on a clear acetate cel. This now served as the position master, which I used to register and position the remaining elements throughout the composite. A photocopy of this was sent to the art director for the client's approval.

Preparing the artwork:
4. In my darkroom I made 12 mattes for each of the 12 dupes and contacted these to produce 12 window lithos.

5. Using the position stat as a guide, I taped one dupe onto an acetate cel, atop the position stat. I followed the same procedure for each of the 12 corresponding dupes. Each dupe had its own window litho taped over it.

6. Using separate acetate cels for each monitor screen transparency, I positioned each over its corresponding dupe.

7. I taped down the 12 individual mattes on 12 separate acetate cels, registering them with the Condit pins.

8. Wherever more than one matte would be required in the exposure of a dupe transparency, I created one matte composite by ganging up those mattes, registering them with the pins, and exposing each of them onto one piece of litho film.

9. For the grid enclosing the computers, I sized a box shape in the perspective and dimensions required from the art director's original comp and my own position stat. I programmed the grid into my computer and photographed it.

10. I mounted the grid transparency and the matte of the computers on separate acetate cels.

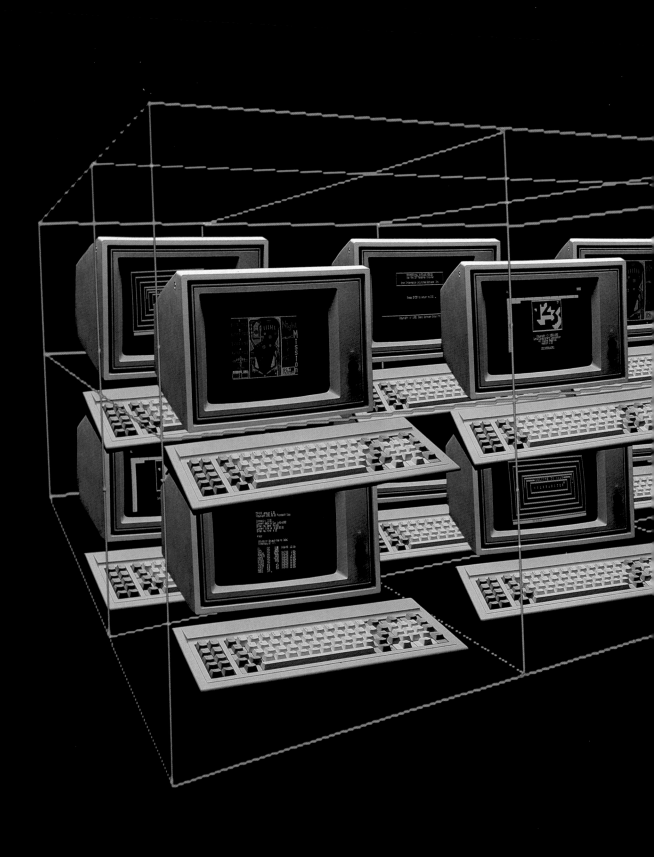

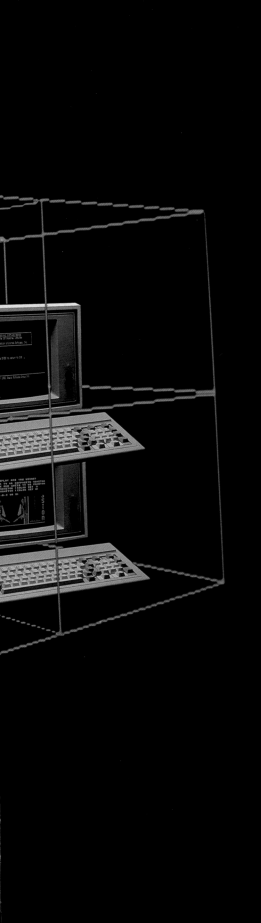

The final composite:
11. I first positioned the matte of the grid on the copystand. (This matte remained in position throughout the compositing.)

12. Next, I positioned the necessary mattes on the workstation, and then I placed one of the transparencies of the monitors. After I made an exposure, I removed all of the artwork except for the grid matte. I repeated the steps with each of the 12 monitor transparencies.

13. I placed an acetate cel, mounted with a clear litho, on the copystand and exposed each of the screen readouts in turn. I then removed all the artwork, including the grid matte, from the copystand.

14. I placed the grid transparency on the copystand and made my final exposure.

PHOTO COMPOSITE WITH BACKLIT GRAPHICS
CAMERA FORMAT: 8 × 10
CLIENT: HEWLETT-PACKARD

This was an advertising illustration for the client's line of fiber-optic connectors. The kaleidoscopic effect was created by a repetitive pattern of eight separate connectors. To accomplish this effect, I had custom-ordered a double-diagonal Condit frame; instead of registration pins on two corners, this special frame had a pin on all four corners, which let me produce an exact repeat pattern of the transparency of the fiber-optic connectors.

STEP-BY-STEP

1. In my studio, I drew an 8 × 8-inch box on a clear acetate cel. I drew connecting diagonals in the "X" of the box. I used this as my guide on my 8 × 10 camera for the layout of the image.
2. I photographed the connectors by placing a single row of them on the piece of glass, carefully arranging them so that all but one would fill all of one side of the box I had outlined in the tracing on my groundglass. The narrow, light gray fiber optic (on the far left of the image) would go in the empty area. I illuminated the set from below with a small light bank. I made sure the light gray connector, on the right, and the large connector, in the center, pointed directly to the center of the box shape.
3. I punch-registered the transparency with my Condit punch and made a matte and a window litho for this image. I then sandwiched the window and the transparency together. This gave me a transparency with a black background.
4. I put the transparency onto a Condit pin-registered carrier in my enlarger and projected

the image of the row of connectors onto a vacuum easel.
5. I positioned a punch-registered matte of the connectors over the pins on the vacuum easel and, using the matte as a guide, I taped the 8 × 8-inch box tracing onto the acetate cel. With this sandwich, I carefully sized and positioned a second, smaller row of connectors.
6. I made a dupe transparency of this row of connectors, reduced in size to the desired proportions of the final image.
7. A matte replaced the dupe transparency in the enlarger, and litho film replaced the duping film on the easel. I exposed the litho film onto the projected matte. I then contacted this matte in the masked registration frame and created a window for the image.
8. I prepared the third row of connectors in the same way, which gave me three transparencies of the row, showing them in corresponding reduction towards the center.
9. The background image was created by drawing tiny dots on Durolene, shooting a negative litho of it, and exposing it through a red filter. Using a dark blue filter, I then underexposed it to produce the final background color.

The final composite:
10. Using the custom-made Condit frame, I placed the transparency of the largest row of connectors on the south quadrant of the box.
11. Placing a sheet of unexposed dupe film in the frame, I closed the back and made an exposure to ensure proper positioning. I removed this film, marking it on an edge for later compositing with the other elements.
12. I then placed the connector transparency on the west quadrant of the Condit frame and replaced the dupe film for another exposure. I repeated this sequence until all four sides were photographed, and repeated it again for the two smaller rows of connectors.
13. Next I made an exposure of the background, first placing the composite matte of the connectors in the registration frame, the corresponding background transparency, and finally, the dupe transparency. The resulting image, at right, was composed onto one piece of film.

The use of a double-diagonal Condit frame was the component that enabled me to create this graphic special effect project. The color and perspective give a dynamic sense of movement to the viewer, as well as representing the products themselves in an interesting layout.

PRINT MONTAGE WITH AIRBRUSHED BACKLIT GRAPHICS
CAMERA FORMAT: 8 × 10
CLIENT: ACTIVISION

The client was looking for a unique twist to its video game promotions and wanted to incorporate some new special-effects graphics. The art director's comp hinted at the need for a print montage; the image would include "creatures" flying around in space trying to attack a futuristic character called the Zone Ranger.

To avoid the time and expense that would be involved in building a whole set, the client approved an alternative design, using airbrushed elements that would be stripped into the photographic image of the Zone Ranger. The model for this principal character was created in the studio. A 16 × 20 C-print of the laser rays and starfield background and a C-print of the Zone Ranger were made. The print of the Ranger was then montaged in position onto the background. The airbrushed "creatures" were added, and reflections on the ranger's dome airbrushed in.

STEP-BY STEP

Creating the background:
1. I created the background sky first, which was a simple backlit color gradation, blending from deep purple to black. I airbrushed black on a clean acetate cel and then covered the finished art with diffusion material. I made test exposures using a purple filter.
2. The laser rays were created by drawing thin lines on a sheet of Durolene. I used the art for the background as a guide for placing the rays on the image area. A negative litho was made from this art. The litho was positioned on a prepunched cel and taped in place on my workstation. I used diffusion material on this also and made test exposures through a pink filter.
3. Once I had these elements in position, it was easy to determine where I would place the explosions. First, I placed the litho of the lasers on my lightbox and overlayed it with a sheet of Du-

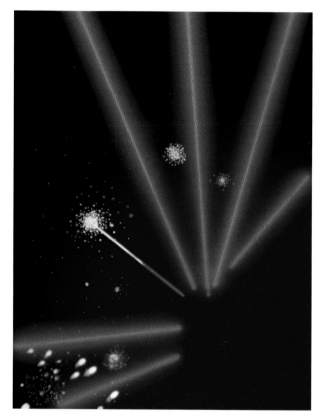

rolene. I then drew on the Durolene tiny dots where I wanted the explosions to be. To give the impression of a beam striking something, I placed one explosion over the end of a laser ray blast. When I had completed the drawing, I made a litho negative of it at 100 percent.
4. At my workstation, I was now ready to composite the three pieces of art: the background sky, the laser rays, and the explosions. The sky background was exposed on my copystand.
5. The laser rays were double-exposed with the explosion art. I did, however, use retouching dyes on the finished transparency to add color to the image.
6. I had two 16 × 20 C-prints made of the finished background composite. An artist was employed to carefully airbrush in the "creatures" to exact specifications.

Creating the Zone Ranger:

7. The set for the principal model consisted of the Ranger with his armoured hands enclosed in a Plexiglas bubble dome. The background was solid black. I illuminated the Ranger with a medium-sized light bank, directing the light from the side. The armoured gloves were illuminated by a direction snoot light, using a red gel over the strobe head.

8. After the ranger model set was complete, I made exposure tests. When I had my best exposure, I made a 16 × 20 print of it. From this print I cut out the Ranger and dome and carefully montaged them onto the background print. Pink reflections were carefully airbrushed to the dome, and small areas were cleaned up. The final print, with all elements in place, was then copied onto 8 × 10 transparency film for final reproduction.

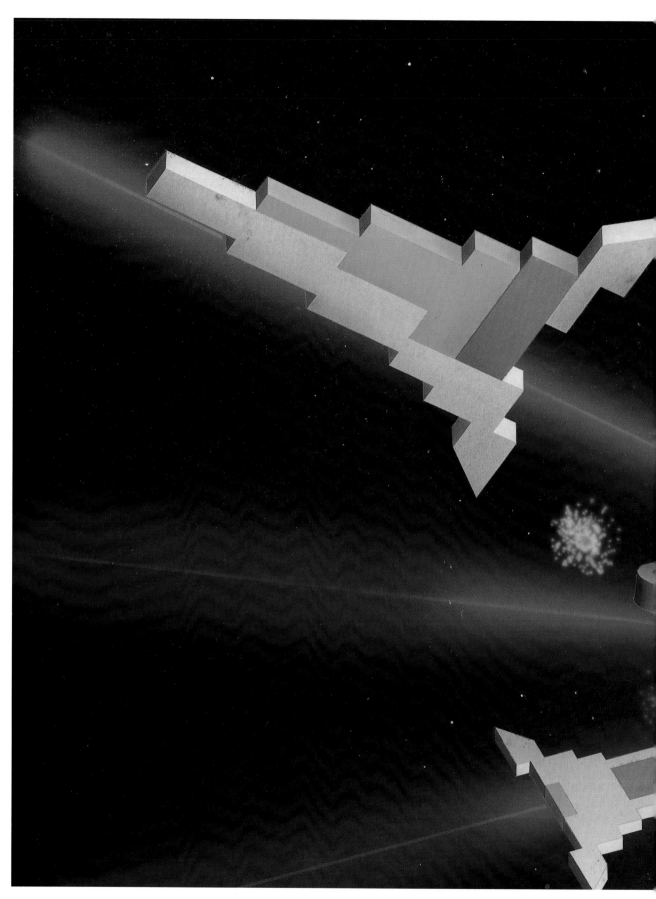

The final ad is a combination of airbrushed graphics, backlit laser effects, and a print montage of the Zone Ranger set. The background starfield was created with diffusion materials and colored gels in the photo composite.

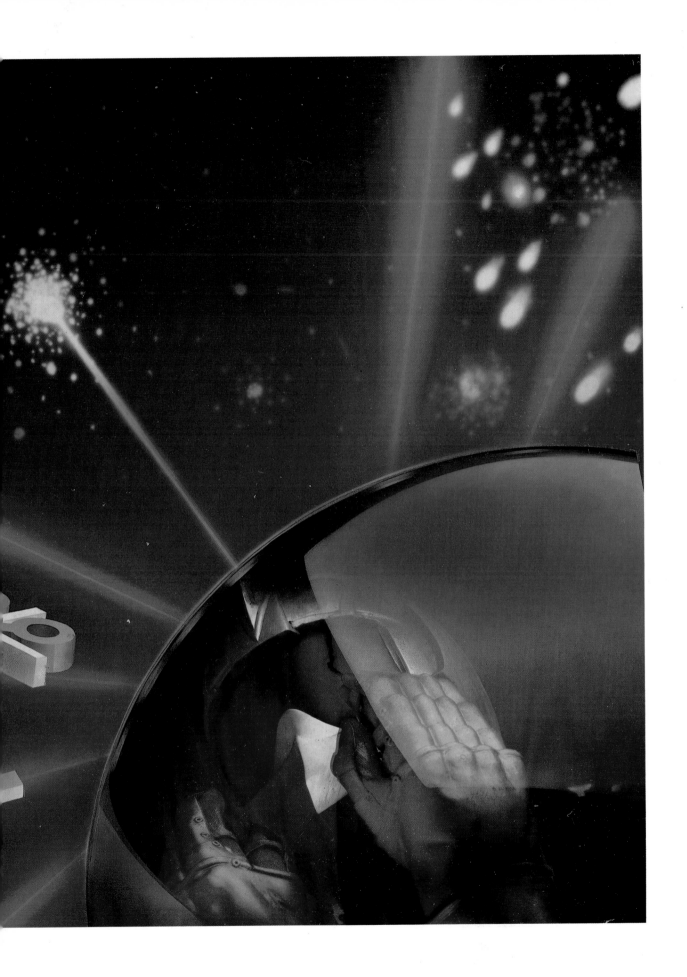

A PORTFOLIO
OF MASTERS

MASTERS
OF THE MEDIUM

© Jayme Odgers

THE FOLLOWING SECTION is a portfolio of some of the exciting work being created in the area of special effects, with an emphasis on the particular techniques described and used in this book. The work of the artists encompasses a wide scope of applications, from the purely commercial projects of advertising and animation, to the more personal visions of individual ideas. In all of them you will find the artistry and graphic sense of their makers. These photographs remind me of what I enjoyed so much about the Surrealists— they added reality to every object in their images, thereby broadening the scope of our imagination.

I hope you will use these examples as a source of creative inspiration. The photographers featured here are all preeminent in their respective fields. In their own words they explain how they solved various visual problems.

The single factor that surfaces in all of these projects is that of the idea brought to life. Whether it be the graphic description of a city of light, a greater universe to journey to, or the simple beauty of a light-drenched still life, the power of an idea has been brought into play and made real in these works. Every one of the images more than suggests the creative energy that inspired it, as well as the sense of fun that often went into making it.

© Pete Turner

The images on this and the following page were both created by compositing two separate subjects. During the compositing process both of the photographs were additionally manipulated and enhanced for special color effects using a Marron-Carrel Optical Printer.

The sun image, above, was taken in Australia. The foreground is actually part of an airport ceiling, which I found very graphic and photographed with a 200mm lens. The sun itself was photographed with a 400mm lens to create a sense of flattened perspective.

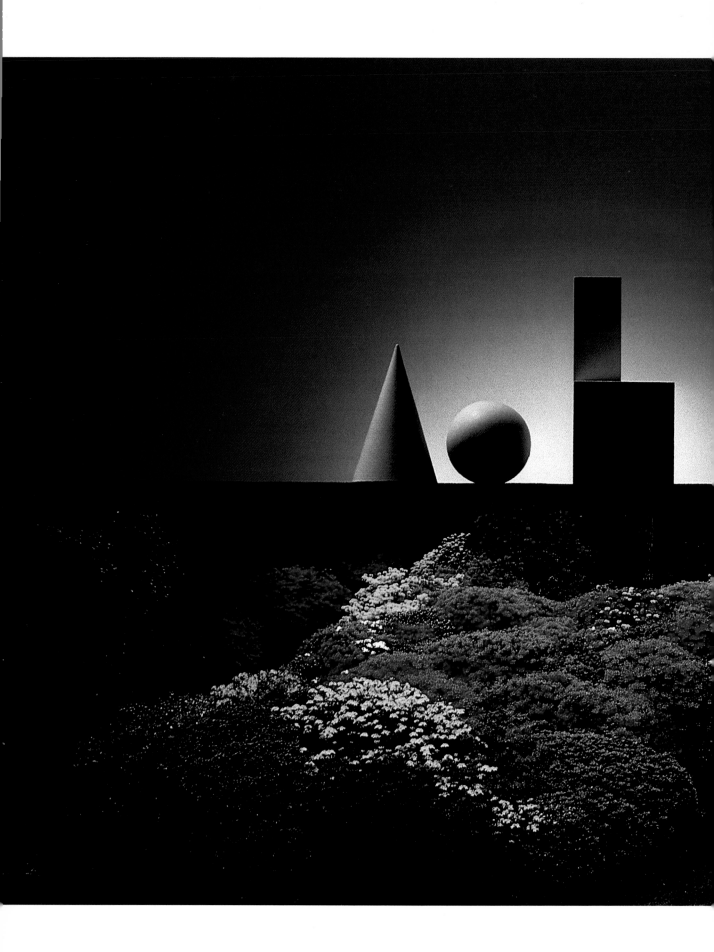

© Pete Turner

This image, of geometric shapes set in a flowered bower, is a composite of an image of a European garden, and a studio shot of the shapes. I used a 105mm Micro Nikkor lens for the studio set, and shot with Kodachrome film—which is what I use exclusively in all my work.

MICHEL TCHEREVKOFF

On a previous assignment, I had worked with images of human cells that had been recorded by an electronic microscope, then digitized and computer-enhanced. I used those photographs as a visual reference for the foreground model of a biological organism built of urethane foam and colored with gold and magenta light. The curved grid creates a graphic frame for the spectrum and gives the image a sense of depth and dimension. To produce the spectrum I used color gels over a negative film. I shot with a fog filter, threw it out of focus to soften the overall feeling, and then double-exposed it, in registration, on the inside of the grid.

PETER HOGG

This advertisement for Genesco/Reebok's running shoes was composed of a miniature set that I built. To this, I added the foliage and spaceship. The shoe was held in place with a steel rod, hidden from view behind it. I wired the shoelace with wire and arranged it to create the illusion of the shoelace going into the spaceship. The image was a multiple exposure in two parts: the set with spaceship and shoe, and another exposure created for the glow effect on the shoe. The only filtration was that required to color balance the film. A diffusion filter was used in the glow, and a mask was created to keep the diffusion from bleeding into the shadow side of the shoe. Ektachrome 6117 Daylight film was used, and later developed and processed at +1 stop.

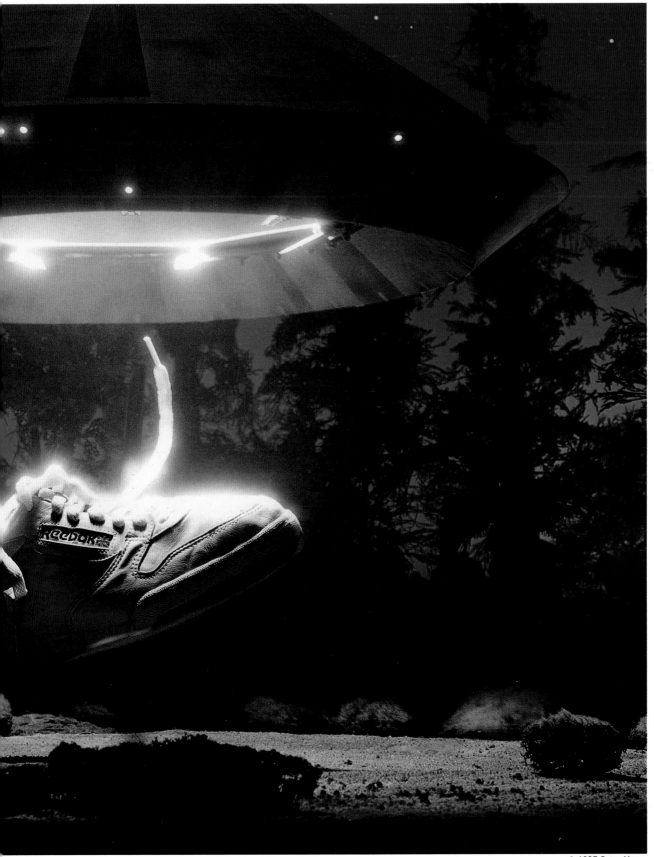

JAYME ODGERS

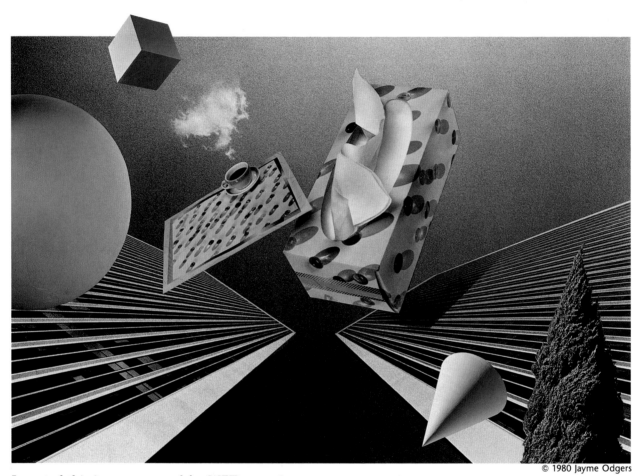

I created this image as an ad for *WET* magazine, to illustrate a product I had on the market—Spacemats—placemats of images laminated in plastic. This image utilizes the idea of simultaneously looking out and looking up. The twin towers of Century City, Los Angeles, and the sky and cloud were the background on which I composited the other elements. Each was printed and montaged using paper-backed photo paper (not plastic), which was then sanded down to the emulsion and adhered to the background with gelatin. This provides an almost invisible edge when I use the print-montage effect.

I knew exactly what I wanted to do when I got the poster commission for this project! I had previously made a photographic self-portrait showing just my legs in a barren landscape: the artist as Mercury, messenger of the gods. This inspired me, and I asked the Olympic Committee for a model athlete with "great legs." They came up with Ellie Daniels, a 1972 gold-medal swimmer. Using a Hasselblad and 40mm wide-angle lens at ground level, I photographed Ellie's legs on the roof of my apartment. Originally thinking

I would strip the legs into another background, I was elated when the exposure I made had the perfect cloud in place. Working with April Greiman, who created a festive, silk-screened background for the poster, I had the idea of making the left leg step out of the picture—to represent the transformation athletes must go through to achieve Olympian stature. The photo and background were stripped together in the final printing process of the poster.

© 1987 Jayme Odgers

This illustration, for Superbowl XXI, was a particular challenge because of the trophy's highly reflective surface. After my preliminary work with sketch comps, I decided on a design incorporating the trophy image apparently being hurled out of the stadium. I also included the flowers and Fifties-fins car to create a California mood. After finalizing the sketch for size and position of all the elements, I went in search of them to photograph.

The Rose Bowl stadium was another difficult subject; I had to get just the right dawn light exposure. Unfortunately, the morning I photographed the neon sign, it was not working. I made an exposure and returned later to get a picture of the lights. I shot with a Pentax 6 × 7, using a fisheye lens and Fujichrome. A trip to the flower district yielded a perfect selection of roses and greenery; I took some and photographed them in my studio. To obtain the image of the sky and mountains, I went to Pasadena about six times to shoot various sunsets before I got the perfect shot. The car, a '59 Cadillac, was photographed at the top of Mulholland Drive at sunset. The palm trees were found on a trek around the streets of Los Angeles.

All the images were then photocomposited into a single 11 × 14 transparency, and this was subsequently duped in an 8 × 10 format so that a 20 × 30 Cibachrome print could be made and retouched. The final processes required some complex work that included using a 4 × 6-foot Duratrans of the completely retouched image and creating masks for the separate elements. With help from master photocomposer Jim Crocker, the resulting image was a success.

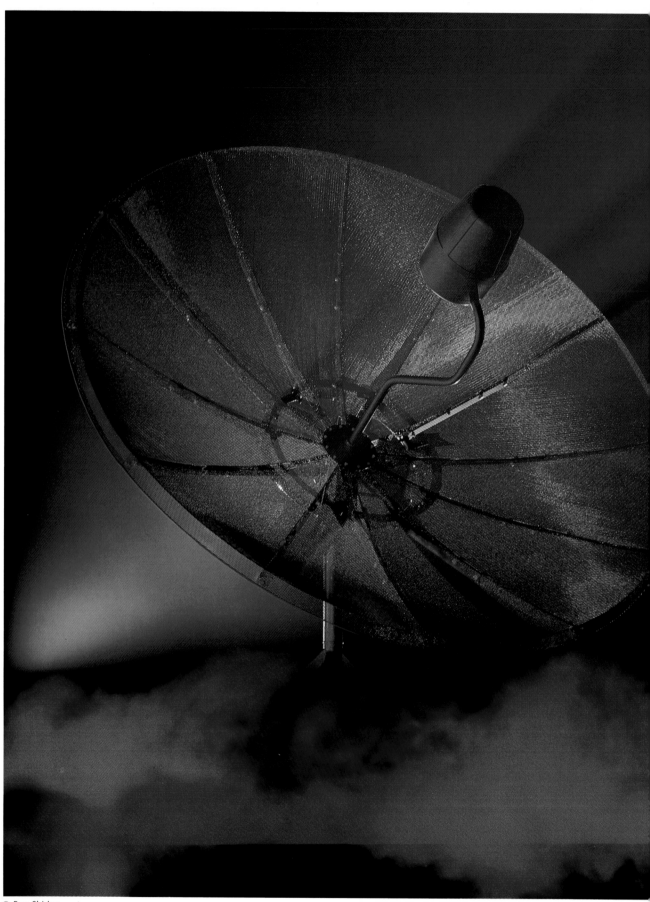

© Ron Shirley

RON SHIRLEY

This satellite dish was created with two exposures: the first incorporated the 10-foot dish, which was assembled in my studio on a platform. I produced the beam of light with a tungsten spot strobe and colored gels. A fog machine helped create the surreal atmosphere. The second exposure was of the cloud effect at the bottom of the frame. Dry ice, water and fire extinguishers were used, lit with strobes and additional gels. I composited both images in-camera, with 8 × 10 Fuji 100D film.

For the agency, Vic Oleson and Partners, my associate Brett Lopez and I created this energetic and fun image of Chevrolet's Spectrum. The image was composited from two sets, the painted backdrop of the city, and another of the car, model, gas pump, and hose. The neon lines in the skyline were all hand-painted. Both of the photographs were printed using a dye-transfer process. The film format was 4 × 5, and I used Fuji 100D film. This was certainly one of the most delightful sets to create and you can tell by the face of the model that we all had a good time producing the image.

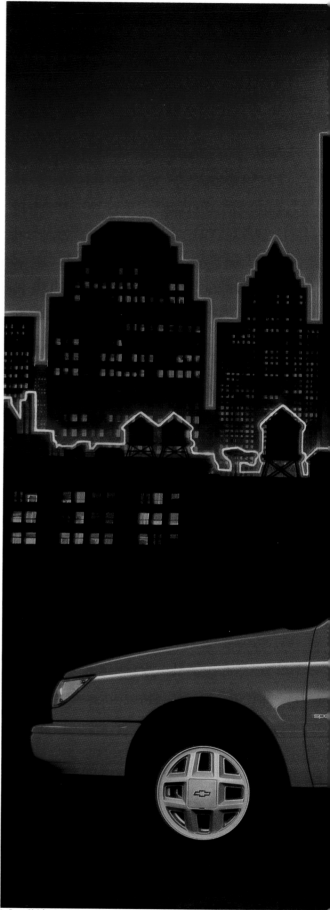

© Ron Shirley

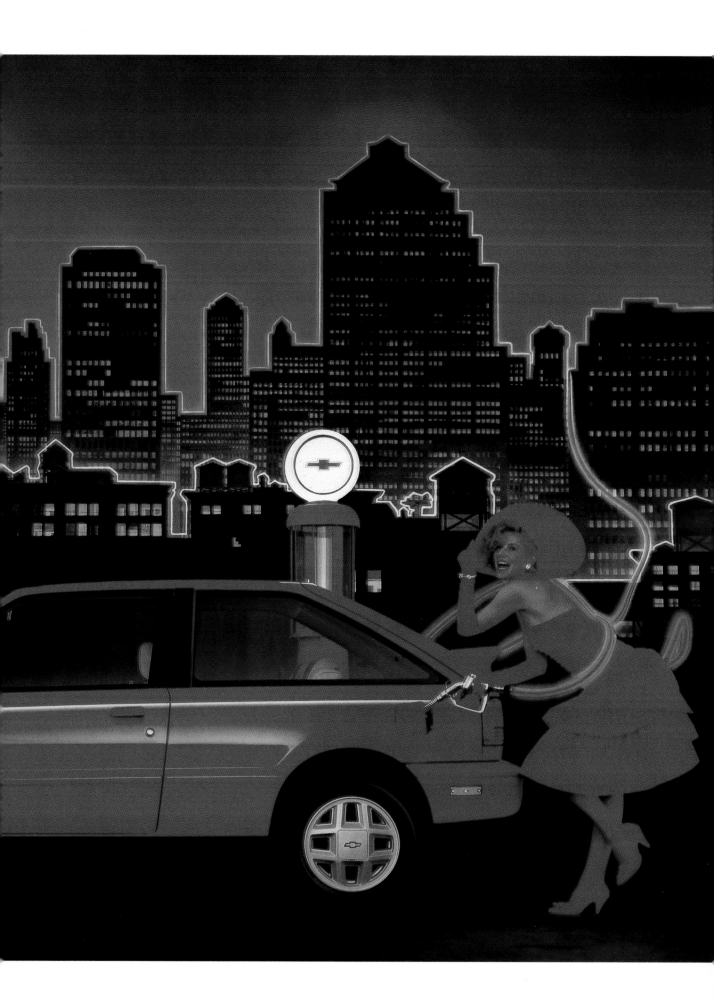

This image, for Torker BMX bicycles, was composited from three exposures. The bike and rider were first suspended by wire 10 feet off the ground for the desired perspective, using a black velvet background to delineate the product. The primary exposure was strobe-lit, with the biker peddling; the second exposure created a sense of movement by shaking the camera. These exposures were then combined with a third exposure of the glow at the bottom of the image, which was created by diffusing a strobe light source against black seamless. All three elements were then composited in-camera for the final image.

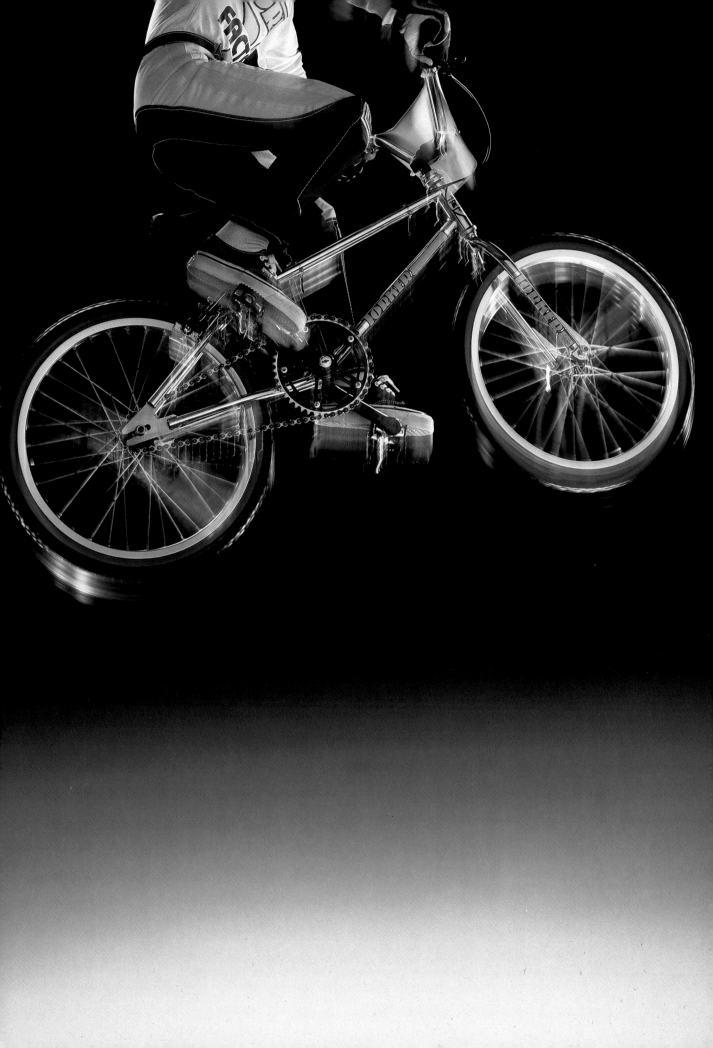

ALAN CHERNIN

I created this image from a photocomposite of two separate sets; the first incorporated the motion effect, the second was an exposure of the bottle itself. Both exposures were made on 4 × 5 Ektachrome film, and I made a precise series of test transparencies before selecting the final image. My equipment was a 4 × 5 view camera, used with a 90mm lens to achieve an illusion of expansion in the bottle.

To produce the zoom effect in the first image, I set up the bottle, lit it carefully with a red gel, and then kept moving it forward at intervals and exposing each time. I checked the registration and recorded the placement of the bottle at each position on my camera groundglass.

The second image, consisting of the bottle alone, was then set up and lit to match the multiple exposures I had taken with the red gels. I used a strobe light in a softbox and a spotlight placed directly behind the bottle to illuminate the dark liquid. The bubbles at the top were created seconds before exposure to give the impression of a just-opened bottle.

KEN RUBIN

This is a photo composite of a 4 × 5 photograph and line art of the streaks and galactic sky. The original image included both the circuit boards as well as the drop-shadow effect. The streaks were created by diffusing two sets of thinly-drawn lines. To make them appear as if they were floating over the calendar while shooting out from the circuit boards, I made a matte from the streak art. I then positioned this under a sheet of Plexiglas, and made a dupe. The other elements were photographed separately and later composited into the image. I used Kodak 6121 Duplicating film on 4 × 5 format.

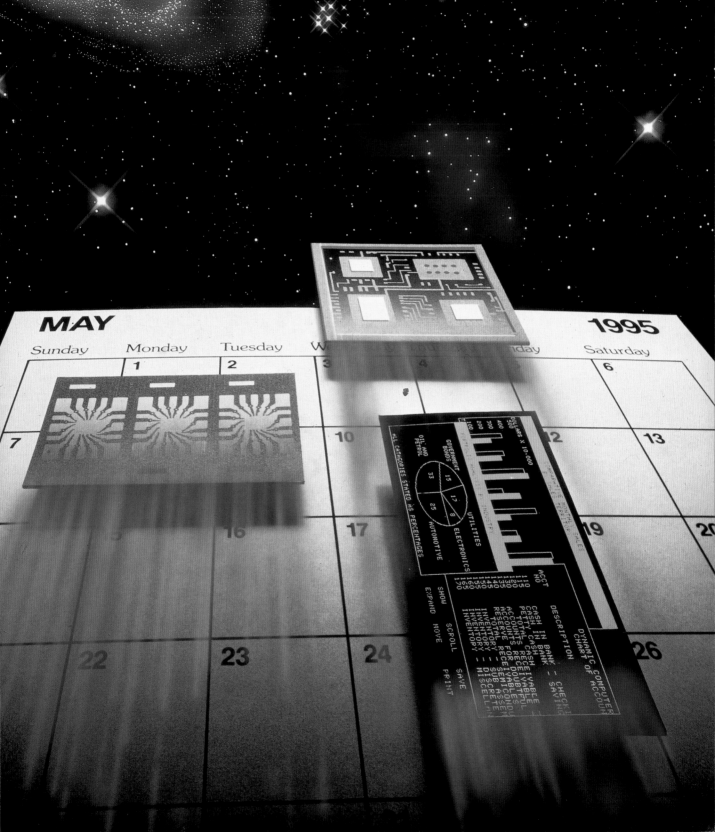

For Trax Softworks, Inc., and its agency, Donna Mercer Design, I was commissioned to illustrate the firm's specialization in "easy-to-use end user software." I incorporated a combination of backlit graphics and photo-compositing methods. The client needed a background that would easily be adaptable for type display, and an image that could be used either as a vertical or a horizontal. All of the artwork was created on a Mac-Plus computer: the grid, the two stars, and the large center explosion. Using very simple shapes, I then created a variety of glow effects with different diffusion materials. After final exposure tests, I created the photo composite of all elements using Kodak 6118 Tungsten 8 × 10 film.

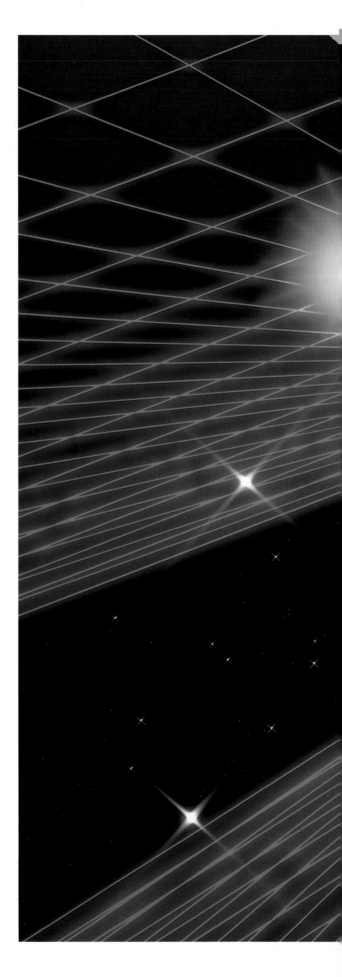

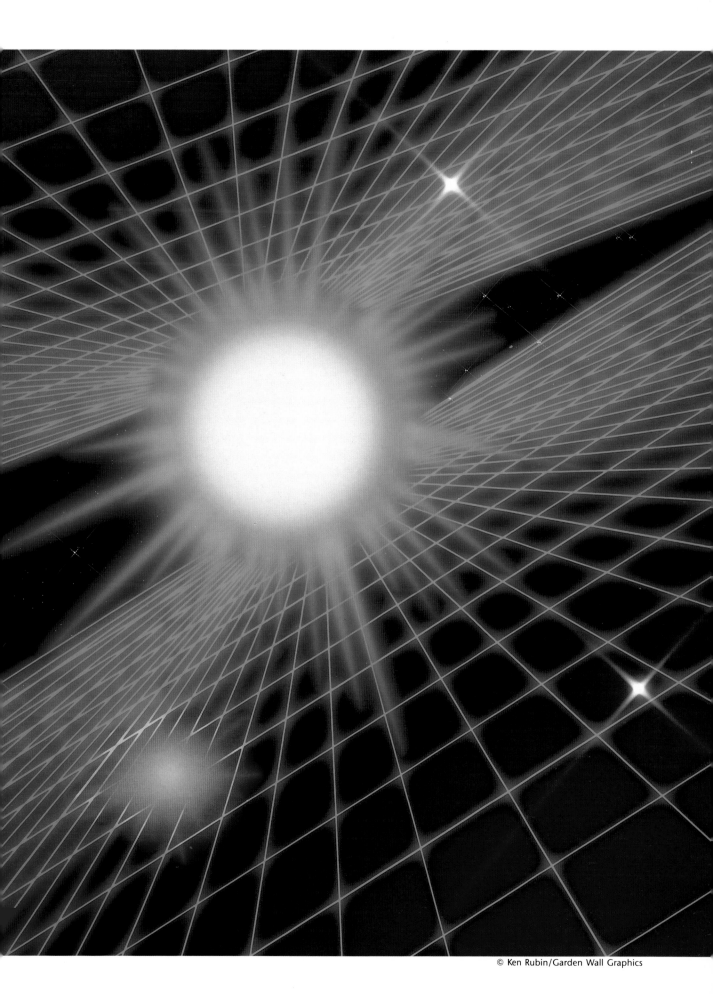

© Ken Rubin/Garden Wall Graphics

MANNY MAES

In this image I was trying to develop a concept using the ideas of cryogenic space travel and simulated life suspension. It is a combination of many techniques of photo compositing and masking. Each element was photographed separately using 8 × 10 Ektachrome film. Working from a comp, I played with each element in various juxtapositions, and finally came up with this graphic placement of them. The comp served as my guide during the masking process for each subject, which were all finally combined in a single exposure.

© Manny Maes Studio

RICHARD WAHLSTROM

This image was an assignment for a billboard for Perkin-Elmer, the company that makes the machine that makes computer wafers. Each of the single wafers was photographed separately and then composited with the shadows and reflections of the sky. All elements were shot in focus to the final size. The reflections were created by using inverted shots at a darker exposure.

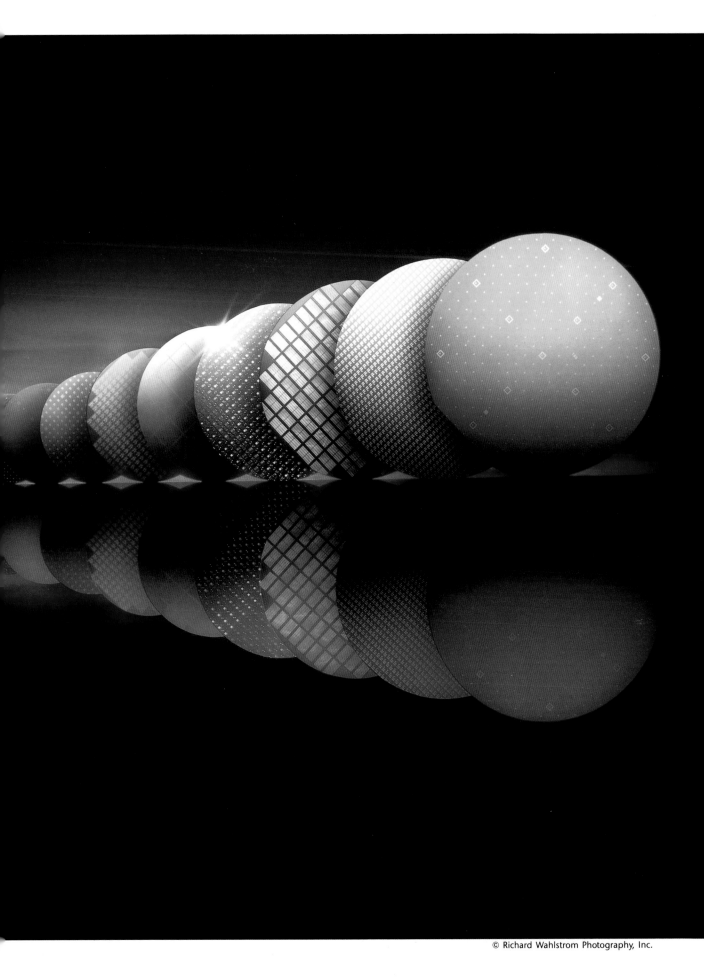

Another billboard assignment, for Christian Brothers and its agency, Carol Williams Advertising, to illustrate that its product "towered" above the competition. A twilight shot of the San Francisco skyline was made first, and then the bottles were photographed to the exact size of the final image and masked into the skyline with gradation filters for a smooth composite. The model was photographed last and then stripped into the image.

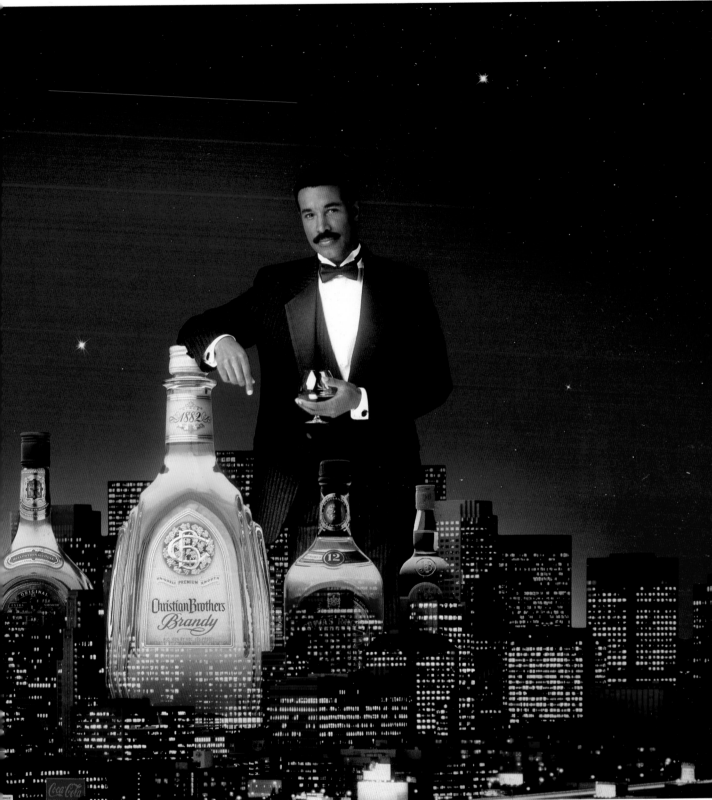

© Richard Wahlstrom Photography, Inc.

Give Me The Right Technology, and I Can Move The World

National Advanced Systems

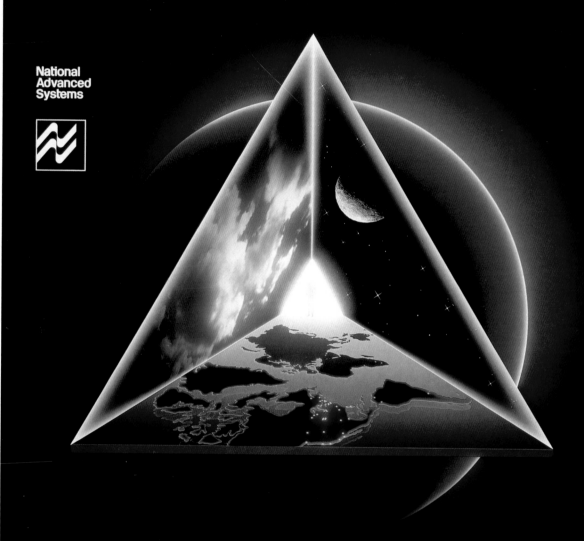

The AS/XL—A Generation Ahead

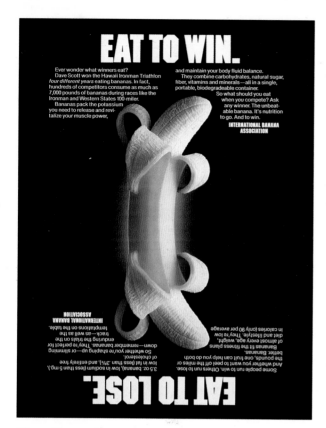

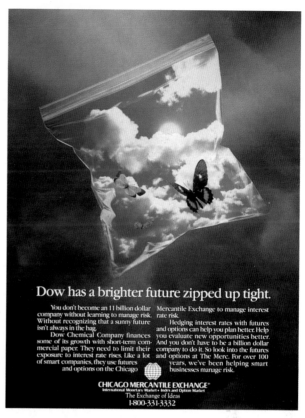

The client, the Banana Board, and its agency, Ketchum Communications, were looking for a twist on a new ad campaign. We sought out a perfect banana, and I photographed it twice—under very exacting lighting conditions. I then cut the image down the middle and pieced it into a single photograph to create the illusion that the banana was peeled at both ends. Our efforts were rewarded with a Clio award.

For Dow Chemical Co., and its agency, Grey Advertising, I played with the idea of butterflies in a packaged environment. The copy explains the concept. I first photographed each butterfly separately, as I did the clouds and plastic bag. The bag was then masked over the dark clouds, except for the zippered section. The butterflies were next masked over the blue clouds. A sunburst was added afterward.

The commercial assignment here, for National Advanced Systems, had to illustrate in one image the three main areas the company deals in: space, land, and air communications and technology. Using the idea of a triangle and a man, I decided to photograph each section in perspective, and have the separate elements leading back to the man's image.

DIRECTORY OF SUPPLIERS

MAIL-ORDER ART SUPPLIES:

WORLD SUPPLIES
3425 West Cahuennga Blvd.
Hollywood, CA. 90068
(213) 851-1350

STOCK ART:

DOVER PUBLICATIONS, INC.
31 East 2nd St.
Mineola, N.Y. 11501

REGISTRATION EQUIPMENT:

CONDIT MFG.
Philo Curtis Rd.
Sandy Hook, CT. 06482
(203) 426-4119

CARTOON COLOR COMPANY, INC.
9024 Lindblade St.
Culver City, CA. 90230

DIFFUSION MATERIALS (Flexiglas, Plexiglas):

STUDIO SPECIALTIES
3013 Gilroy ST.
Los Angeles, CA. 90039
(213) 662-3031

GEM-O-LITE
5525 Cahuenga Blvd.
North Hollywood, CA. 91601
(818) 766-9491

PRE-FABRICATED COVES:

SINAR BRON
17 Progress St.
Edison, N.J. 08820
(201) 754-5800

TEKNO/BALCAR
751 No. Highland Ave.
Hollywood, CA. 90038
(213) 662-3031

STUDIO SUPPLIES:

STUDIO SPECIALTIES
3013 Gilroy St.
Los Angeles, CA. 90039
(213) 662-3031

COPYSTAND EQUIPMENT:

BENCHER, INC.
333 West Lake St.
Chicago, IL. 60606
(312) 263-1808

BOGEN PHOTO CORP.
17-20 Willow St.
P.O. Box 712
Fair Lawn, N.J. 07410-0712
(201) 794-6500

DARKROOM VENTILATION SYSTEMS:

KYVYX KORP.
P.O. Box 1002
San Francisco, CA. 94083
(415) 877-8368

GLOSSARY

ACETATE Clear, plastic material used to mount backlit artwork and transparencies in copystand photocompositing. Single sheets of this material are also called CELS.

ACETATE INK An ink which is used specifically for drawing on acetate. It will not smear or blot up on the surface.

AIRBRUSH A tool used to apply paint or ink in a controlled amount. It works by a combination of compressed air and an ink-release mechanism. The artist can control both the amount and the flow of ink or paint onto a surface. It creates very even, gradated surfaces, as well as a range of other effects.

BACKLIT The illumination of any art or transparency with a light source. Used primarily in copystand work, this technique has a wide range of applications and effects.

BACKLIT GRAPHICS Any artwork produced using techniques of backlighting on a copystand workstation.

"C"-CLAMP A curved stand with clamps, used to hold objects that will be photographed. Also a type of lighting device sometimes used on copystands to attach lights at the same level to the copystand baseboard.

CIBACHROME A color-positive printing process which offers rich tonal values, high contrast, and high color saturation.

COMP A rough sketch of a design. Comps are used by many artists and photographers to indicate the size, color, and arrangement of elements in a prospective design project.

COMPOSITE To combine single photographic images onto one piece of film.

CONTINUOUS-TONE The full range of tonal values in a gray scale, from deepest black to white. Also, any photographic or printed image including these tonal values.

COPYSTAND A mechanical device composed of a baseboard, elevating shaft, and camera, on which reflective art or photographs are copied. Used to create backlit graphics when the baseboard is adapted for illumination. They are commercially available in a variety of models.

DENSITOMETER An optical device used to measure and balance color and exposure values in photographic slides, negatives, and prints. Often used with transparency guide strips when working with special-effects exposures.

DOUBLE-EXPOSURE A single image composed of two exposures on the same frame of film. A multiple-exposure involves more than two exposures on a single frame of film. These can be created in-camera, or composited during enlarging and printing.

DUPE A duplicate transparency of an original exposure. Used in reproduction for print.

DUROLENE Plastic material on which to draw comps and artwork.

EMULSION SIDE The side of the film which is coated with photo-sensitive chemistry. It usually appears matte, or dull. In some materials, such as rubylith, the emulsion is lightly coated with a thin glue, and adheres to any surface it is positioned on.

FIELD CHART A sheet of acetate material on which have been inscribed vertical and horizontal numbers. These numbers are reference points used to position and size artwork on the copystand work surface. In photocompositing, it enables the exact alignment of separate elements in a single image.

FLEXIGLAS A thin, plastic material used to create diffusion effects in backlit graphics.

GRADATION The even transition of one color from dark to light, or the blending of one color into another.

GROUNDGLASS The surface plate, usually glass or plastic, on which the photographic image is viewed. Many groundglass surfaces have a grid etched on them.

LITHO (NEGATIVE AND POSITIVE) High-contrast, graphic-arts film used in copystand work and backlit graphics. It reduces the gray values of any image to either black (negative litho), or white (positive litho).

MATTE The exact outline, or silhouette of an object. A matte can be made from photographic film, such as litho material, or from rubylith.

MYLAR A highly reflective, chrome-like material used to create highlights or to add light values in a given scene.

OPAQUE A thick substance, usually white, applied to art or film to prevent a specific area from being exposed by light.

PANTONE COLOR A translucent, plastic material available in a wide range of colors. The material can be applied to specific surfaces or areas in any artwork or film.

PIN-REGISTRATION SYSTEM A device used to accurately register all separate elements in photo-compositioning work. It is composed of a pin-registration bar on which are slots and a center pin that correspond to pre-punched holes in acetate cels, which are placed on top of one another on the pin bar.

PLEXIGLAS Plastic diffusion material used in copystand backlit graphics.

RUBYLITH Thin, red-colored plastic material used to create mattes. One side is coated with a glue, to enable the user to position it down and cut evenly around it.

SOFT FOCUS A blurred, or diffused effect. This can be done with diffusion material, such as Plexiglas and Flexiglas, or with special soft-focus filters attached to your camera or enlarger lens during copystand work.

STAT A high-contrast photo reproduction of artwork used as a position guide.

STROBE Electronic flash. Simulates daylight illumination (5500K).

TRANSPARENCY A color-positive image; there is no negative for any print. The actual image is created in the film emulsion itself. Slides in 35mm format are the most common examples of these.

WATT-SECOND A measurement of electronic-strobe output. The higher the number, the greater the output of light.

INDEX

Martin Sage has worked extensively in photography and film media. During a period in the Navy, he worked in the field of public relations, investigations, and reconnaissance as a photographer. After completing his training at Pasadena's Art Center/College of Design, he joined Sullivan and Associates, becoming part of an award-winning (a Clio in 1979) team that produced film projects for ABC-TV, ABC *Late Night*, *The Edge of Night*, and ABC *Daytime*.

Sage has worked with Midocean Motion Pictures as a special-effects cameraman, and went into business for himself as a special-effects still photographer. His many commercial clients have included Atari, Disney, Hewlett-Packard, McGraw-Hill, Rohm, Suzuki, Vivitar, and Xerox. Martin Sage resides in Burbank, California. This is his first book for AMPHOTO.